CHEPSTOW AND THE RIVER WYE FROM THE SEVERN TO TINTERN

FROM THE COLLECTIONS OF CHEPSTOW MUSEUM

ANNE RAINSBURY

The History Press

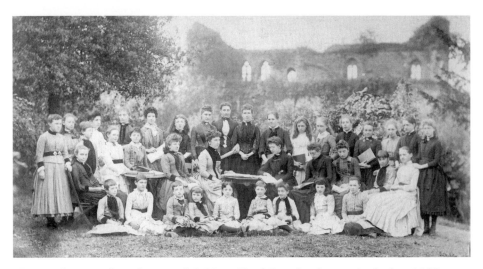

Gracing the grounds at the rear of St Maur, No. 8 Beaufort Square, in the late 1880s, were the pupils of the school for young ladies run by the Misses Thomas (see also page 72). Some studied poses for the camera of Chepstow photographers Tame & Ballard.

Front cover illustration: Looking up High Street from below Bank Square *c*.1909 (see page 85).
Back cover illustration: Chepstow's Town Gate hung with a carcass displayed by butcher Henry Nicholas who stands chatting outside the shop which he had occupied since 1883. Next door, on the corner of Welsh Street, were the offices of auctioneers, valuers and surveyors Davis, Newland & Hunt. Looking through the arch, in this 1900s view, Herbert Lewis' then new premises, built in 1902, give the High Street its familiar, characteristic skyline.

First published in 1989
This edition first published in 2009

The History Press
The Mill, Brimscombe Port
Stroud, Gloucestershire, GL5 2QG
www.thehistorypress.co.uk

© Chepstow Museum, 1989, 2009

Chepstow Museum is part of Monmouthshire County Council
Museums Service

The right of Anne Rainsbury to be identified as the Author of this
work has been asserted in accordance with the Copyrights, Designs and
Patents Act 1988.

ISBN 978 0 7524 5019 3

Typesetting and origination by The History Press
Printed in Great Britain

CONTENTS

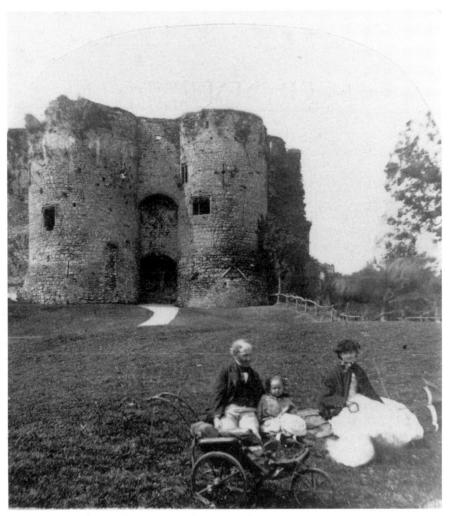

Chepstow Castle has been a tourist attraction since the late-eighteenth century when the Wye Valley was visited for its romantic and picturesque scenery. Here Victorian visitors, *c.* 1860, enjoy sitting on the grass like their contemporary counterparts. The ghostly forms of a horse that moved in the length of time that the photographic plate took to be exposed can just be seen on the right of the picture. The child, however, was being held firmly in position!

INTRODUCTION

Photography has been with us for some 170 years – the official announcement of its birth was made in January 1839. From that year the first practical processes for producing photographs became available. In the last twenty years, since this book was first published in 1989, the new digital technology has revolutionised the taking and making of photographs. Film, slides, and darkrooms have almost gone. Gone too is the feeling of anticipation at collecting processed films and looking at the prints to see how, or even if, the pictures came out! Now there need be no mistake – the end result appears instantly on the screen. The combination with mobile phone has made carrying a camera commonplace, and taking photos even more popular. But how many of these are kept? How many are ever printed out, as digital photo frames allow slide shows to be shown in the home, and the internet to share photos with friends, and strangers! But how will the digital photos taken today find their way into museum collections, so that images of the events and celebrations, and the drastic changes being made to our towns and landscape are preserved locally for future generations...

The new technology has also drastically improved the way photos can be copied and reproduced. Now that the means to scan old photos is generally available, more thought should be given to depositing original old photographic prints in the museum where controlled conditions can ensure their long term survival.

Whereas now everyone can own and use a camera, when photography began the equipment and processing were elaborate and expensive. No evidence has survived to show whether Chepstow had an early enthusiast of the art, someone who might have recorded the end of Chepstow's days as a busy and important port for, by the mid-nineteenth century, the port was in decline together with all the associated trades of wooden shipbuilding, rope and sailmaking, which had continued for centuries alongside the river Wye.

Chepstow was still a bustling market town, with a river carrying trade and well-established as a tourist 'resort', when photography came onto the scene. In the 1850s Chepstow was visited by travelling photographers who set up studios in some tradesman's premises and stayed for anything up to six months, advertising their life-like portraits which, 'beautifully coloured by an experienced artist ... resemble the finest miniatures of the Old School.' Chepstow's first resident photographers appeared in the 1860s but nearly all their known work is portraiture in the 'carte-de-visite' format popular at that time.

Chepstow Castle became a focus of interest for professional landscape photographers just as it had been for artists during the previous century and photographic views of the ivy-clad ruins of Chepstow and Tintern began to replace engravings and

lithographic prints as souvenirs. However, the recording of the life of the town, of local events, group and team portraits, as well as local views of all kinds, began in earnest in the 1880s with the work of Chepstow photographers Thomas Tame and Edmund Ballard.

For more than a century, photographs by professionals and amateurs have preserved numerous vivid images of various aspects of Chepstow life. They are invaluable for the study of the recent history of the community and form an important part of the Museum's resources for reconstructing a picture of the town's past. As present developments continue to change the face of the town – removing old familiar buildings, absorbing open spaces, creating new skylines – that picture becomes a more remote memory, and one unknown to many of the town's ever-growing population.

Buildings may be the landmarks by which a place is recognised, but it is the people who live and work in them who create the character of the town. Old photographs have left us records of their social life, but they are often harder to fully appreciate than landscapes or townscapes. Without identification, many photographs of events and people are merely attractive, sometimes quirky or amusing; interesting on the level of 'how people looked in those days'. It is only when we know something about them that they really start to inform us about the past. Where memories fade, research can often identify and then reconstruct the event. Put together with the relevant programmes and posters the photographs take on more significance and, with eyewitness reports from newspapers or magazines, not only the moment captured by the camera can be savoured, but the minutes before and after, the days or weeks of planning that led up to it, and its aftermath. These contemporary reports allow the 'soundtrack' to be added to the visual record and often not only what was being said, sung or played, but the very atmosphere of the occasion can be recaptured and the static scene become almost animated. Within the space of the captions of this book, it has only been possible to include snippets of the information and descriptions that exist, to suggest something of the background, or a hint of the flavour of an event. Hopefully it will give an indication of the increased significance a photograph acquires through research and interpretation.

Much information can lie locked in an image and finding the key to it can be an exciting and fascinating process. There are still photographs in the Museum's collection about which little is known and some are included in this book. Perhaps someone will be able to help turn the key. It is constantly surprising how new pieces of information – the recognition of a face, some discovery from a documentary source – can suddenly click it into place. Any information about any of the photographs is warmly welcomed and knowledge and identifications accumulated in this way are vital. Likewise the growth of the photographic collections at Chepstow Museum depends largely upon the support of local people. Over the sixty years of the Museum's existence, the collections have continued to expand thanks to their generous donations.

All the photographs used in this book come from the Museum's collections. However, the selection reproduced here is not representative of the overall nature and balance of the collections. It does not reflect some of its particular strengths; for instance the numerous photographs of Chepstow Operatic and Dramatic Society or pageants at Chepstow Castle, both of which have been the subject of entire exhibitions at the Museum. Also, a photographic record of the products of the Bridge Works and Shipyards, from around 1900, has been steadily growing. This is particularly important as the Works have been the major manufacturing industry of the town

since the 1850s and the fate and fortunes of shipbuilding have directly affected the shaping of Chepstow. The choice of these engineering photographs has erred very much on the side of general and human interest.

The basic objective of this selection was to try to produce a broad picture of the town and some of the activities of its inhabitants, as well as to follow the river Wye from its mouth to Tintern, with stops following in the steps of early Wye tourists at Piercefield and the Wyndcliff. A subjective choice of 'good and interesting' photographs was made within that framework. Chepstow Castle, of course, has inspired numerous photographs but, because the main difference between early and present day views is the profusion of ivy, photographs chosen here concentrate on events enacted within its walls. As might be expected, following the Castle, the town centre attracted more photographic attention than other streets. The arrangement of the pictures in the book, which is by location, reveals areas which were less photographed or where there is a lack of photographs in the Museum's collections. If anyone can help to 'fill the gaps' the Museum will be able to reflect a more complete picture of the town and its surroundings for understanding and appreciation, now and in the future.

As well as 'topographical gaps', there are some types of photographs less well represented in the collections than they might be – for instance, photographs of individual shops with their proprietors and the understandably rare interior views of all kinds (houses, schools, work-places), people engaged in 'everyday chores', accidents, floods or fires – subjects which were either of less interest to most photographers or harder to take. Hopefully, some gaps may be filled. The Museum's collections are constantly growing, thanks to the interest and support of local people.

A primary concern of the Museum is always the preservation of its collection, so that it can be enjoyed and studied by future generations. Few people realise the fragility of photographs, but the usual ways of enjoying them – passing them from hand to hand, pointing out people, displaying them framed on walls in bright light or above fireplaces or radiators, or even keeping them in the albums commonly available – all hasten their deterioration. Handling, light, humidity, most plastics and papers are harmful to these sensitive chemically complex objects. At Chepstow Museum great care has been taken to provide the right conditions to prolong their survival.

Of the many obviously delicate objects in the Museum's collection, photographs rank high in the requirements for special care.

This small selection from the Museum's photographic collections has been arranged as a tour in the hope that it will be easier to find one's bearings, recognise places and compare changes through time from one photograph to another. Where better to start the tour of Chepstow than at the Castle, since its foundation in 1067 marked the beginning of the growth of the town around it.

CHEPSTOW PROFESSIONAL PHOTOGRAPHERS

Some of the photographs can be attributed to known Chepstow professional photographers. Only those which have the photographer's mark on the photograph, or stamped or printed on the mount or backing, have been included in this list.

The photographs are identified by the page number followed by 'a' or 'b' etc., to indicate the position on the page working from top to bottom (and left to right where applicable).

ALFRED DUNMORE, *c.* 1868–71. His studio is recorded on the back of this carte-de-visite as 'Beaufort Gallery'. In an 1871 trade directory he is listed in Welsh Street. 98b.

THOMAS TAME was a chemist at No. 19 Moor Street from 1878 who developed an interest in photography and had a studio at the back of his shop. 80, 93a.

TAME & BALLARD. In 1885 Thomas Tame gave up the chemist shop and, in partnership with Edmund Ballard, kept the Chepstow Photographic Studio in the room behind No. 19 Moor Street until 1887 when they moved to 10a Welsh Street. 2, 24, 94.

EDMUND BALLARD continued the Chepstow Photographic Studio at No. 10a Welsh Street, which he was running by himself in 1890, for over 30 years. He took many group and team portraits and recorded events and entertainments, as well as producing views and studio portraits. 10a, 12, 13a, 18, 21, 38b, 69b, 81a, 81c, 86a, 92b, 108b, 112, 113b, 117b, 121b, 122, 124, 125b, 147, 149.

W.A.E. CALL was in Chepstow 1905–1910. In late 1905 William Call first advertised his business as 'Photographic Artist' and as teacher of Music (he had recently been appointed organist at St Mary's Church, Chepstow) from his address at Mount Rose, Gloucester Road, Tutshill. By 1908 he was at St Ewins Bridge Street. Call moved from Chepstow to

Monmouth where he had his 'County Studio' at No. 3 Priory Street. 14, 17b, 28, 34a & b, 62a, 113a, 125a, 129a, 130a, 131a, 142, 143a & b, 146a, 152, 155b, 157c.

EDWIN J. JENKINS had a studio at No. 14 Beaufort Square, early 1920s. 70, 88a, 102, 106b, 119, 129b.

A.N. COMLEY, Beaufort Square, *c.* 1930. 22b.

JACK HUBBARD ran the *South Wales Argus* Chepstow office in the 1930s–40s. 31a, 61b, 64 a & b, 67a & b, 87a & b, 100a, 105b, 118a, 123b, 128a.

RAY DUMAYNE had a studio in the old Palace cinema, 1950s. 10b, 107a.

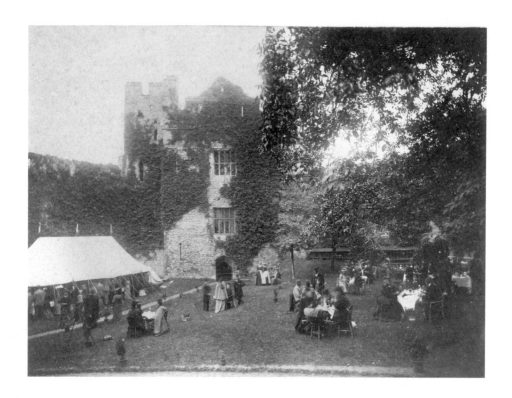

Chepstow Castle took on new life in the nineteenth century as a place for fetes, shows and entertainments, by courtesy of its owner the Duke of Beaufort. Here refreshment is being taken at tables under the shade of the enormous walnut tree which dominated the first court. It was said to be the largest walnut tree in the country and its spread of branches became so heavy they had to be propped up (see below). Honey fungus finally caused its death in 1961 when the age of the uprooted tree was determined to be 600 years.

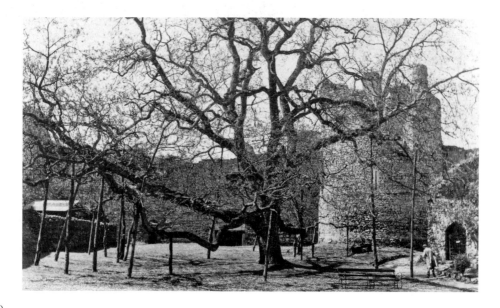

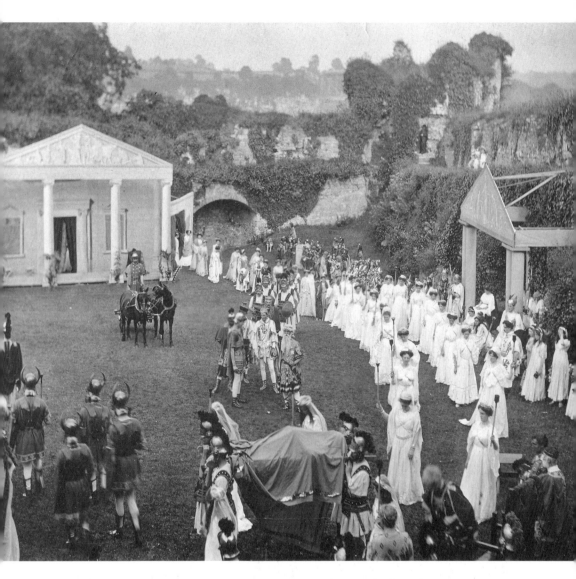

The siege of Troy was re-lived in Chepstow Castle in 1909. This was the last of a series of spectacular events held there since 1889. Their purpose was to raise funds for the restoration work being carried out on the parish church. The first pageant had been particularly successful in this, raising some £470, and encouraged further and increasingly elaborate events. The vicar, Revd E.J. Hensley, was actively involved in the pageants, showing a flair for adapting stories into plays. However, the chief organizer was Walter Clifford Thomas and under his direction the pageants became events attracting large numbers of visitors from long distances. For three days the castle would be transformed according to a theme; after English medieval, Norman and Elizabethan had been gone through in 1889 and 1890, Ancient Greece arrived in 1891, Eastern tales in 1893 and the legends and histories of Spain in 1895. At night the performances of plays and tableaux were repeated by limelight with the processions by torchlight and coloured fires illuminating the castle. Although fund raising fetes continued to be held, pageants on a similar scale did not take place until 1907. The new vicar, Revd Percy Treasure, was equally enthusiastic and took part in these productions. The scene above shows Hector's funeral procession, finale to the final pageant.

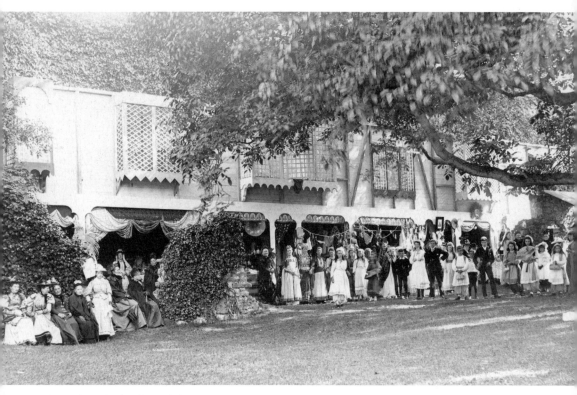

The scale and splendour of the 1890s' pageants is captured in the photographs. These also show some of the features that had been established as a pattern for the events.

Above: A street in Damascus was recreated in the first court of the castle in 1893 as part of the Eastern fete. The stalls, which made a significant contribution to the funds raised, were imaginatively decorated in keeping with each pageant's theme. In this bazaar 'for the sale of rare merchandise from the far orient', the lady and gentleman 'stallholders' became merchants from India, Baghdad, Turkey, Algeria and Arabia and there were 'flower merchants from Cashmere and sweetmeat merchants from Persia'.

Opposite above A grand procession of all the performers heralded the start of the event. It allowed the magnificence of the costumes hired from London to be fully appreciated, and by torchlight at night the effect was said to be dazzling. In this photograph the characters come from the *Siege of Granada* play in the Spanish fete, 1895. Several hundred characters processed along the curtain wall and down the steps by the Great Tower, through the second court and into the first for the formal opening. This ceremony, which took place each afternoon, was performed by a lady of the local gentry or nobility beneath the walnut tree, with the participants and visitors gathered around (see page 15).

Opposite below: A series of tableaux based on stories of the same period or place was staged as well as the play. In 1895 Don Quixote made an appearance at the Spanish fete. Here he is having an encounter with a Biscayan squire. The organizer of the tableaux that year, Mrs Maples, was praised for her thorough drilling of the 'living pictures', the result showing that 'she had reached the ideal of the art of posing her subjects'.

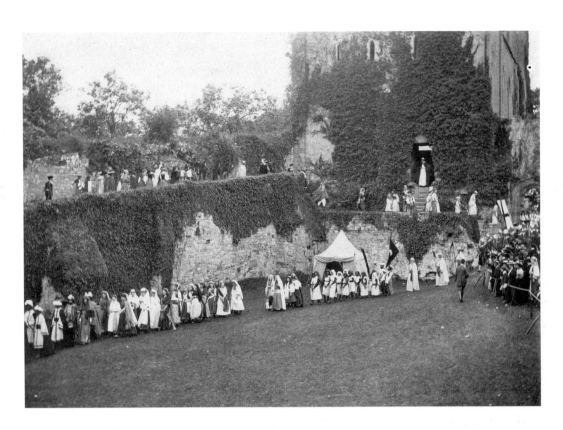

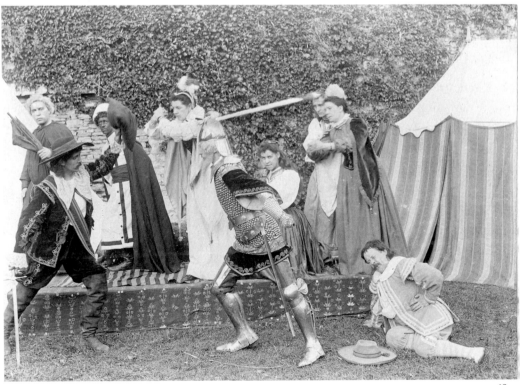

13

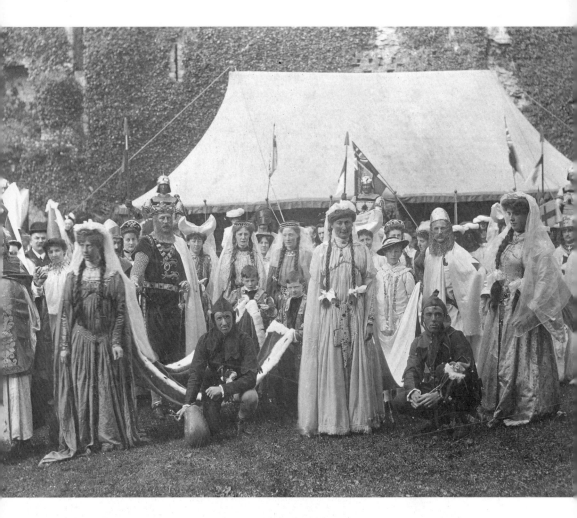

A revival of the pageants on something approaching the grand scale of the 1890s was seen in 1907. A performance of *The Talisman*, a story of crusader knights, was the centre-piece of the event. It had been done before, in 1893, as a part of the Eastern-themed pageant, and W.C. Thomas gave freely of his experience to the organizer of the 1900s' fetes, Willie Davies. The event was eagerly anticipated and some splendid photographs survive of which these are just a few, but they do not betray the sad reality of the day – that it was cursed by bad weather. Although the rain kept off during the performance of *The Talisman* it had kept people away, and a downpour brought the first day to an early close. The next was even worse, with torrents of rain and hail turning parts of the ground into a quagmire, just over an hour before the start. The postponement of the show until 4 o'clock was announced through the streets by the town crier. Luckily by then the rain stopped and the pageant could begin.

Above: Characters in the crusader camp, Richard the Lionheart and his court.

Opposite above: The traditional opening ceremony beneath the walnut tree. Mrs Marling of Sedbury Park opened the first day's proceedings on 3 July, Miss Clay of Piercefield Park the second.

Opposite below: At the close of *The Talisman* '24 maidens attired in dresses of various hues executed a pretty cymbal dance, the effect being very fine indeed'.

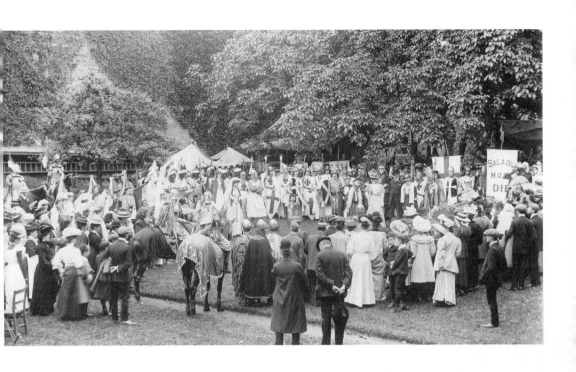

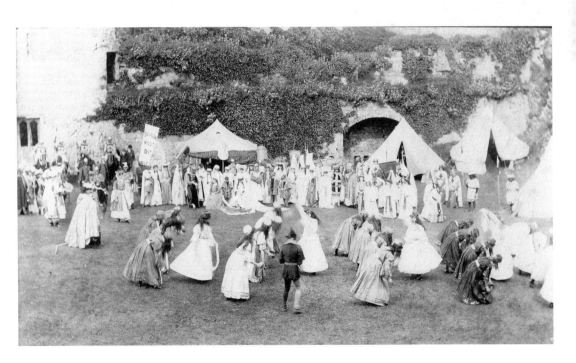

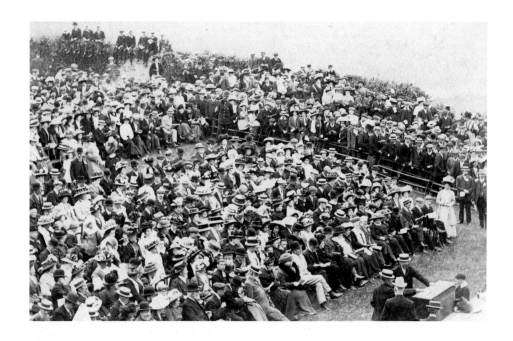

Brass Band and Choral Contests in Chepstow Castle became popular annual features of Whit Tuesday attracting considerable crowds as the photographs show. It was a novelty for Chepstow when, in September 1897, the first competitions took place as part of a Grand Demonstration of Friendly and Trade Societies. An address on Friendly Societies and State Aided Pensions was part of the programme on that occasion but, despite the torrential rain that fell that day and the abandonment of one competition because the only entrant failed to turn up, the success of the event inspired its repetition for 17 years until the outbreak of the First World War and its resumption for some years thereafter.

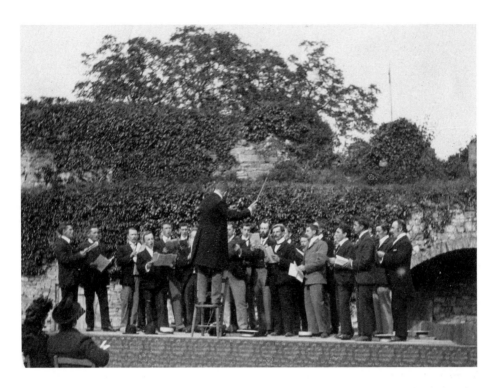

The programme always began with a procession of the competing brass bands playing from Mount Pleasant through the town to the castle. In addition to two contests for brass bands and a male voice choir competition (the backbone of the programme) innovations came, and stayed, including solo competitions for soprano, tenor, baritone and contralto, mixed choir, piano solo for under 16s, while others came and went, such as recitation and the juvenile choral competition. The photograph below almost certainly shows the Chepstow Nightingales being conducted by EGR Richards. They were successful in the juvenile choral competition in 1907.

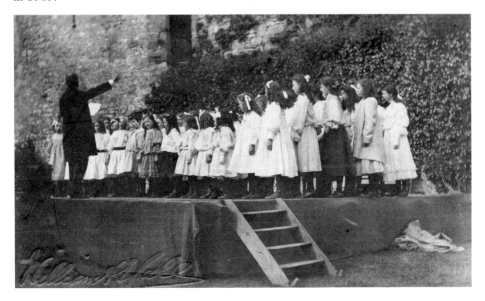

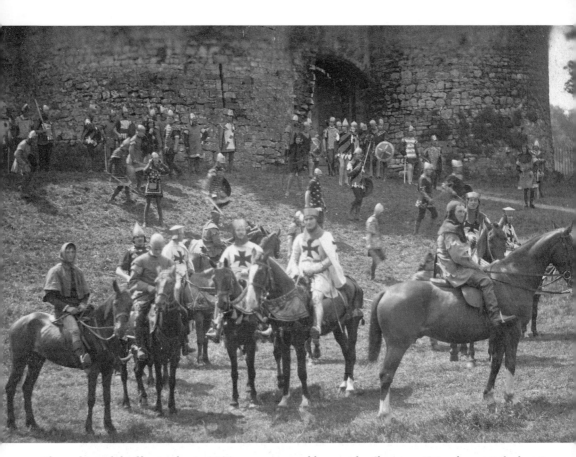

The making of the film *Ivanhoe* in 1913 was a memorable event for Chepstow. Not only was it the location for this great feature film in those early days of film-making, but also hundreds of local people took part in it and even more watched them, an experience that they all had the thrill of re-living at numerous showings of the film thereafter. Remarkable now is the short period of time required for the whole enterprise, said to be 'the biggest venture of the kind ever attempted in England'. The first intimations of the Imperial Film Company's interest in Chepstow Castle were mentioned in early June, negotiations for its use two weeks later; filming finished on 15 July and the film was released in September. For those three or four weeks in 1913 Chepstow took on 'a state of festival and fancy raiment'. All the hotels were full of Norman knights and damsels with American accents, the local 'supers' or extras apparently went about their work in costume, and reporters from national newspapers and the film press came to see how a 'great cinematograph picture is taken'. They gave high praise to the making of the battle scene. The sack of 'Torquilstone' caused two days of great excitement involving an army of 200 locals – the Bridge Works virtually ceased to function. Enthusiastic participation resulted in a number of injuries, mostly minor, and many broken 'weapons'. The whole film, a loose adaptation of Walter Scott's classic, had a cast of 50 horses as well as 500 people. Ivanhoe was played by the then famous American star 'King Baggot'. Under the direction of Herbert Brenon 20,000 ft of negative were exposed by the two cameramen, out of which 3,500 ft made the final three-reel film. In the photograph above, taken during a break in the battle, the two central Knights Templar are Robert W. Edgar (left) and Alfred Proctor (right).

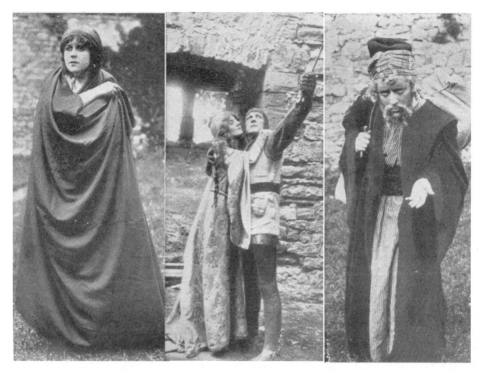

The stars: Leah Baird as Rebecca (left), Evelyn Hope as Lady Rowena with King Baggot as Ivanhoe (centre), Herbert Brenon, producer and dirctor, as Isaac of York (right).

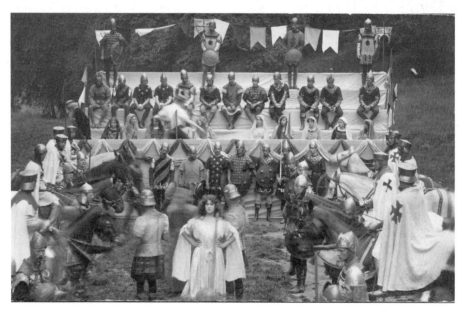

Rebecca's burning at the stake, one of the final scenes, was filmed on the last day before a large crowd in the upper part of the Castle Dell. Elaborate preparations included local Willie Davies' 'effective and tasteful decoration of the stage'.

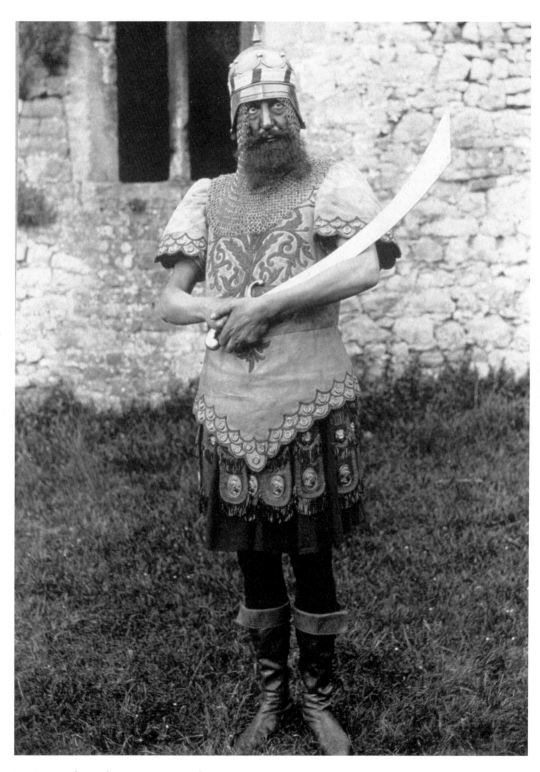

Mr Cartwright as the Saracen in *Ivanhoe*, 1913.

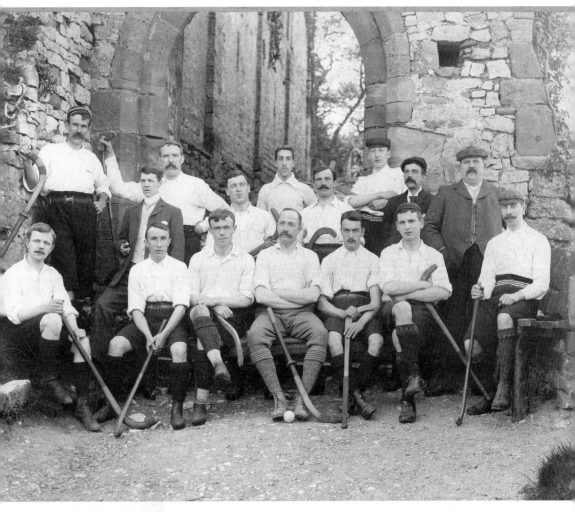

St Mary's Hockey Club posed in front of the entrance to the gallery by the Great Tower. Chepstow Castle provided a superb backdrop for portrait photographs and it was especially used by various local sports teams over the years. This photograph records the last season of St Mary's Hockey Club as they joined with the Chepstow Hockey Club in 1901. The amalgamated clubs formed a powerful combination, losing only 3 out of the 20 games in the next season and, in 1907, beating Wales by 2–1. The members of St Mary's Hockey Club in their 1900–1 season. Back row, left to right: W. Kelly, J. Hutchings, H. Watkins, W.G. Gough. Middle row: A.G. Hoare, R.J. Goss, M. Mills, G. Hutchings. Front row: H. Dean, R. Richards, C.R. Thomas, C.H. Clarke (capt.), E. Higgins, A.T. Saunder, G. Watkins (Hon. Sec.).

A series of garden parties was held in Chepstow Castle in 1903 as the fundraising events that year in aid of the restoration of the parish church. At the third of these 'two teams contending in a game of donkey polo provided a great attraction, the roars of laughter which greeted the grotesque efforts of the players to play the scientific game testifying to the delight of the spectators' (*Parish Magazine*).

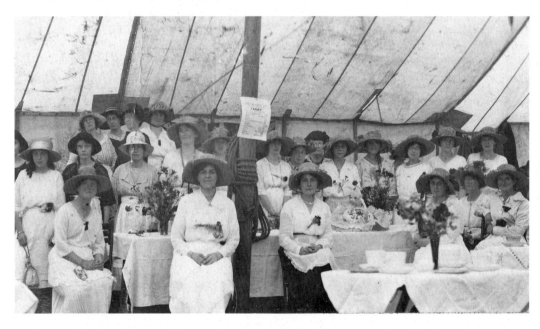

Fundraising fêtes for Chepstow & District Hospital became notable events at the castle from the 1920s. As well as a carnival parade, fairground side-shows and stalls, there were various talent competitions. Mrs Gordon Edwards (third from right, seated) organized the refreshment tent providing 'excellent teas and delicious and appetising suppers ... at very moderate prices' (fête programme, 1930).

An historical pageant was masterminded by the past master of Chepstow Castle pageants, Walter Clifford Thomas, as part of Chepstow's celebrations of George VI's Coronation on 12 May 1937. The theme was Queen Elizabeth I's visit to Kenilworth Castle where the Earl of Leicester entertained her in lavish fashion with balls, masques, pageants and illuminations. However, resources limited the recreation of events to the day when the Queen and her court attended the revels and dances of the country folk. These were reproduced with the help of many schoolchildren who performed maypole and country dancing. Elizabeth and her court were played by members of the Chepstow Operatic & Dramatic Society shown processing in the castle (right), and engaged in a stately dance in the Castle Dell (below).

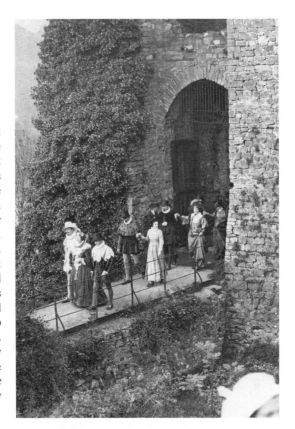

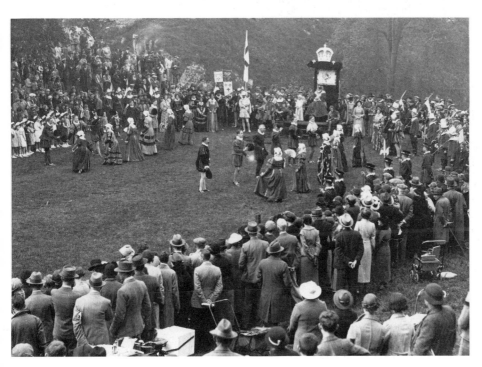

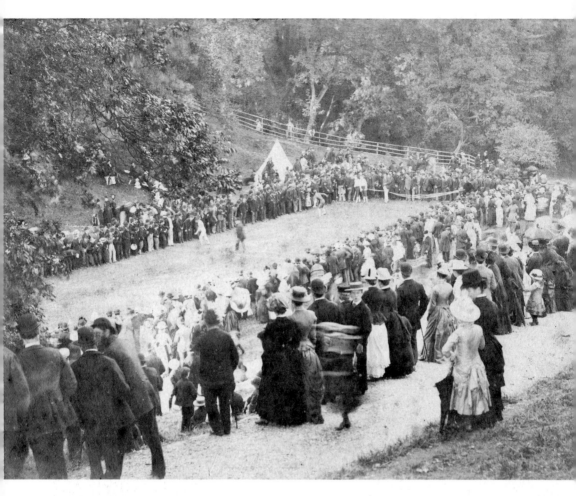

A programme of amateur athletic sports was part of the day's festivities organized to celebrate the opening of the Castle Dell on 11 August 1886. Perhaps the most spectacular and remarkable part was the grand procession in which local working people from businesses and industries in the town displayed their wares and demonstrated their skills, and members of Friendly Societies paraded their banners and regalia to the accompaniment of three brass bands. This elaborate procession paraded the town before reaching the Dell for the opening ceremony. The Duke of Beaufort had agreed to grant the Castle Ditch, as it was previously known, to the town as a public garden for the nominal rent of 1s. a year for 60 years. The Local Board had carried out improvements to the paths and general appearance of the Dell and constructed a 'main road' through it. A promenade concert and magnificent display of fireworks concluded the day's celebration of the Duke of Beaufort's generosity and the town's acquisition of a recreation ground.

Like any successful event the formula is often repeated and, the following year, when Queen Victoria's Golden Jubilee was celebrated, the programme for Chepstow's festivities once again included athletic sports in the Castle Dell in the afternoon, as well as a promenade concert and, of course, fireworks. Tame & Ballard were present at both events and took this photograph.

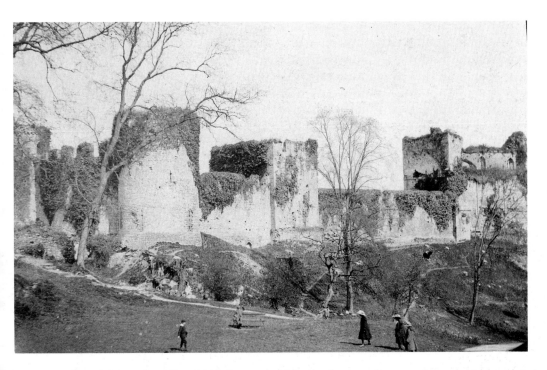

A winter's day in the Castle Dell, *c.* 1910. It was a children's play area then as now.

A lime-kiln was built in the Dell, probably during the late-eighteenth century, at the base of the south-west tower of the castle, part of which, including one of the arrow-slits, can be made out behind the trees at the right of the picture. This rounded tower is prominent in the photograph above. Chepstow and its immediate environs has been extensively quarried for limestone, used for building and roadmaking, and which, when heated, produced lime for mortar and farm use.

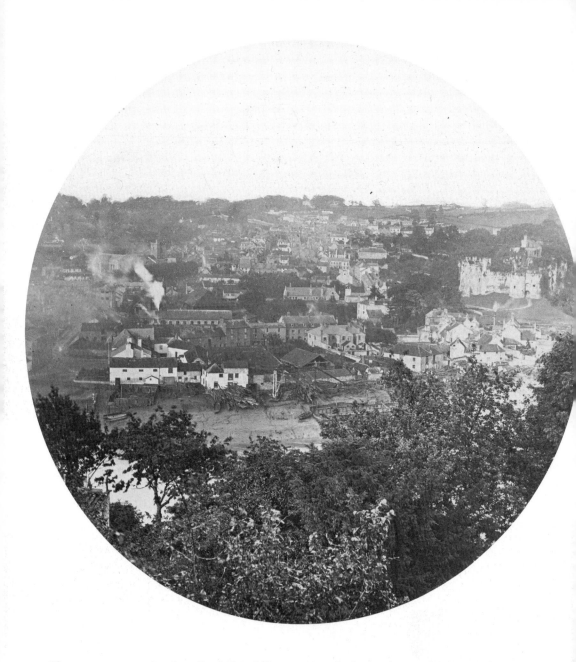

Three panoramas, taken from Tutshill at different times, which are of particular interest for the riverside detail. The earliest (opposite above) shows piles of timber in part of George Fryer's yard stacked up on the riverbank, in front of the stone-built barkhouses. The Board School, built in 1878, is absent on this photograph but is visible on the above, as are Somerset Cottages. This 1880s view shows the tall building in Lower Church Street, then part of the Bobbin Factory, as also, it seems likely, was the building which later became the Drill Hall. On the riverbank far left, are the salmon fishery's buildings and compound, which on the third photograph (opposite below) taken in 1928, includes a boat shed.

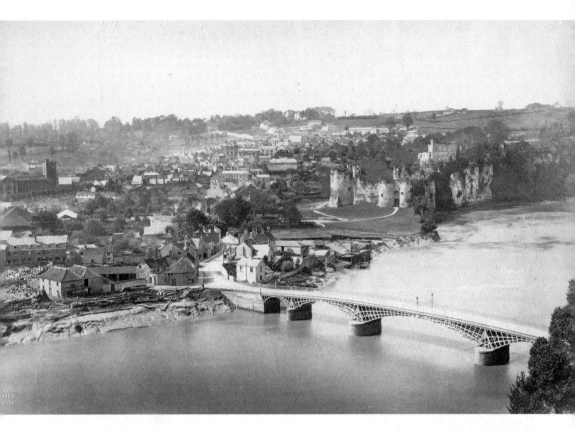

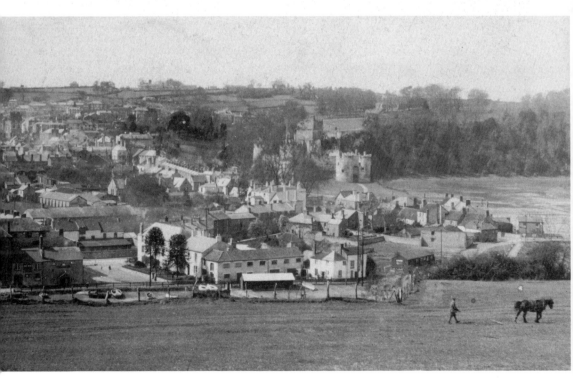

27

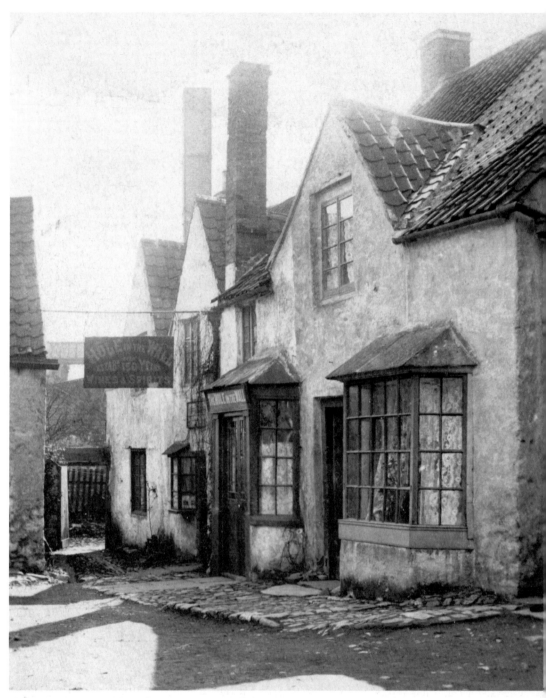

The Hole in the Wall proclaimed on its sign that it had been 'established over 150 years' in this photograph *c.* 1906. The inns shown on these pages are two of the many around the riverside area which were open when Chepstow was a busy port in the late-eighteenth and early-nineteenth centuries. Until its closure in *c.* 1909, the Hole in the Wall was frequented particularly by fishermen and shipyard workers – it backed on to Finch's Bridge Works. The site is now the brush factory car park.

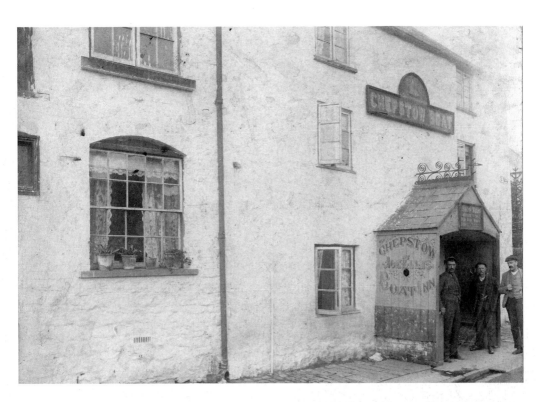

Above: The Chepstow Boat Inn, stands on the edge of what was once the dry dock which, when in full swing, no doubt created much custom for the inn. In the late 1840s it silted up, was filled with rubbish and remains an open space. Standing outside are Jack Cumper, Jack Phillips and Joe Ellis who was the landlord from 1906–23. A boilermaker and salmon fisherman, horse owner and trainer, he also had a steam launch for taking tourists on river trips, renamed the *Francis Bacon* in support of Dr Owen's theory (page 138).

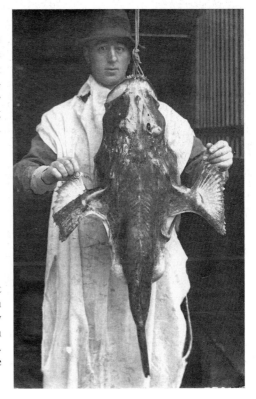

Right: This angler fish was caught in the River Wye at Chepstow by B. White on 28 August 1920. Salmon was the usual catch from the River Wye and widely acclaimed for its quality but, every now and then Chepstow fishermen found strange fish in their nets. They often exhibited these at the Bridge Inn or the Chepstow Boat, alive or dead.

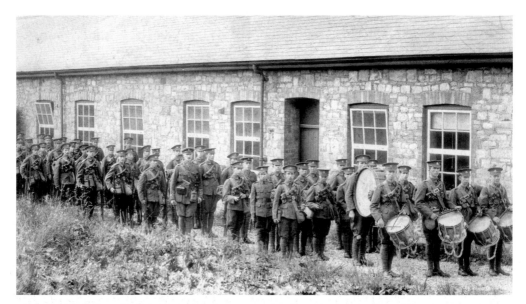

Outside the Drill Hall in Lower Church Street, members of the Territorial Army 1st Battalion Monmouthshire Regt. E Company face the camera. At the opening of the hall in July 1913 a stirring appeal was made for recruits. The Chepstow Company then stood at 70 strong under the command of Capt. C.A. Evill. The Drill Hall soon found a variety of uses – one of the first was as an armoury for the weapons used in filming *Ivanhoe*.

The office building of Edward Finch & Co. Ltd's Bridge Works built in 1903. The wall with its decorative ironwork infill has completely disappeared and the fine brickwork of the building, constructed by John Hobbs of Chepstow, long masked by stucco and paint is once more revealed.

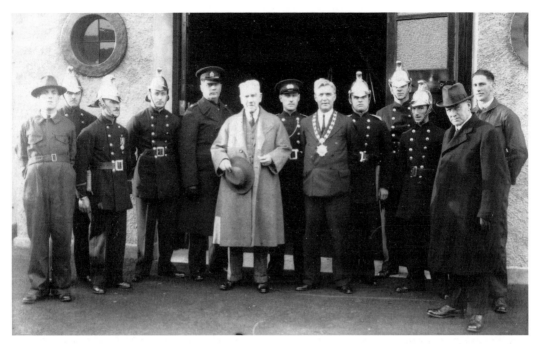

At the opening of the Fire Station on the corner of Lower Church Street in December 1938, was Cllr. W.C. Thomas (in the light overcoat), who was a founder-member of the Volunteer Fire Brigade in 1887. They raised money to buy equipment, including a steam engine in 1897 which, after Alfred Proctor became captain in 1911, was towed to fires by motor car. When the Brigade was reorganized in the early 1930s the Council was persuaded to buy a modern motor engine (below). The fire station was opened by Council Chairman T. Laing (with chain) with, left of him, Cllr. N.F. James (Brigade Capt.) W.C. Thomas and Inspector Basson.

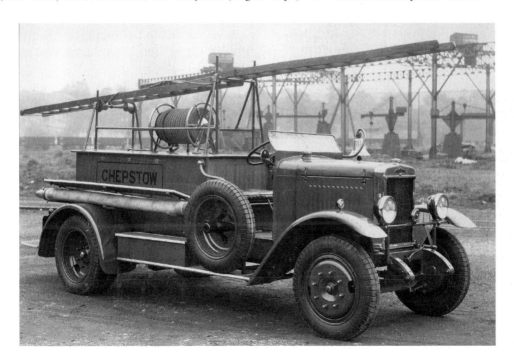

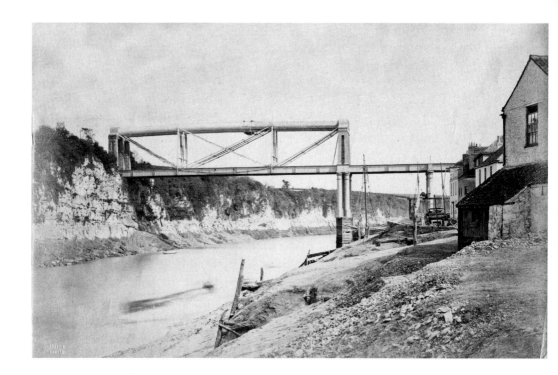

The quayside from the bottom of the filled-in dry dock to the Tubular Bridge. The tubes are being given a coat of paint by the man in the cradle just over half-way along. On the riverbank is a cart belonging to Henry Gillam who ran the weekly market boat to Bristol, a sailing sloop called the *Chepstow Boat*. Part of the quayside between the Town Slip and the railway bridge was known as Gillam's Wharf by the end of the nineteenth century. The building in the foreground stood in front of the Boat Inn.

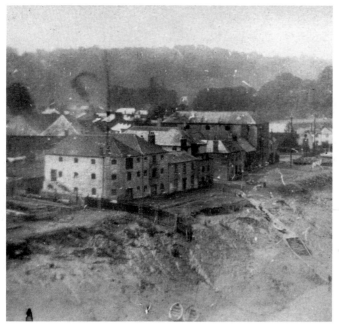

Left: View taken from the tubular bridge looking upriver showing the riverside buildings. In the foreground is the fence marking the boundary of the engineering and shipyard. The Town Slip is visible sloping down the muddy river bank. At one time a house was provided nearby for the cleaner of this stone landing place. Farthest along is the large outline of the warehouse known as the Corn Stores, rebuilt as Riverside Mill flats in the late 1980s.

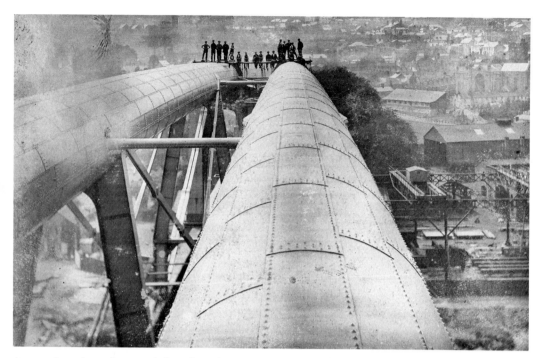

A rare view along the top of the tubes of Brunel's railway bridge, taken in June 1909 when men from Finch's Bridge Works were doing repairs. To the right the gantries in Finch's yard are visible.

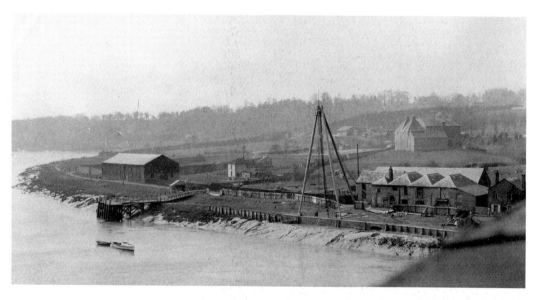

View from the tubular bridge taken in Easter 1916, looking downriver, across the area of open land which was known as the Meads. Nearest to the bridge are warehouses, sheerlegs hoist, the landing stage opened in 1907 for pleasure steamers and, further back, the large buildings of the Malthouse. Just over a year later the view would be transformed by the building of National Shipyard No. 1.

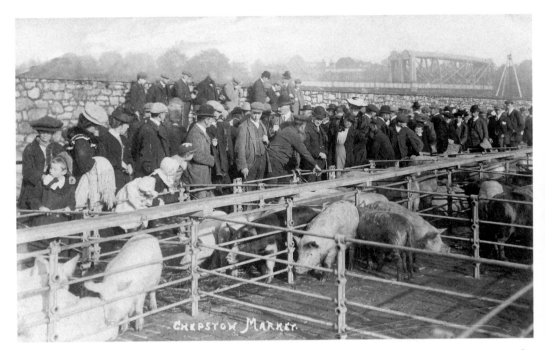

Chepstow's Cattle Market was on the Meads, between the railway station and the river, near to the Malthouse. When the market opened on 28 November 1893, it was forbidden to sell livestock in the streets of the town or obstruct the pavements with pens or hurdles. Up until that time animals had been sold in the streets, with all the accompanying dirt, smells and inconvenience. The market became surrounded by the Shipyard during the First World War. It was moved and re-established in 1922 on land between the parish church and Station Road where it remained until its closure in 1967.

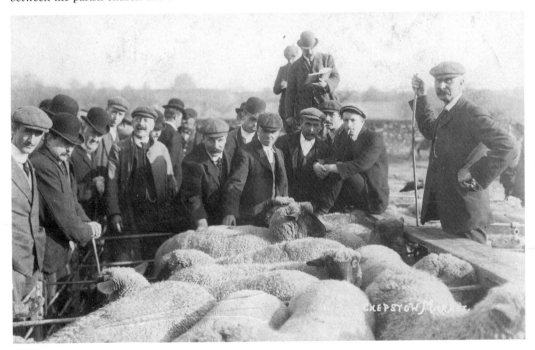

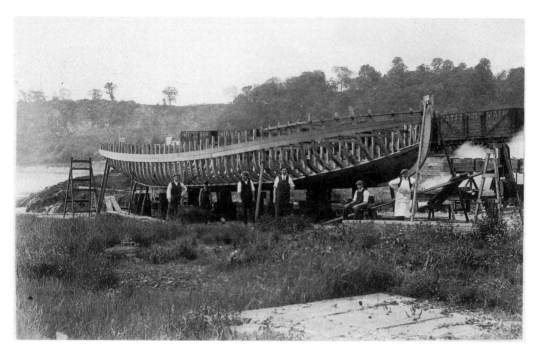

The *Princess Ida*, the first of Enoch Williams' Beachley-Aust car ferry fleet being built in 1931 by Hurd Bros. & Henderson. The stem-post was chosen from an oak tree in Sedbury Park. Members of the Hurd family had built wooden vessels at Chepstow since the 1890s. While earlier Hurd vessels were constructed at Gunstock Wharf (now riverside gardens), the *Princess Ida* was built on one of the shipyard slipways, then owned by Fairfields.

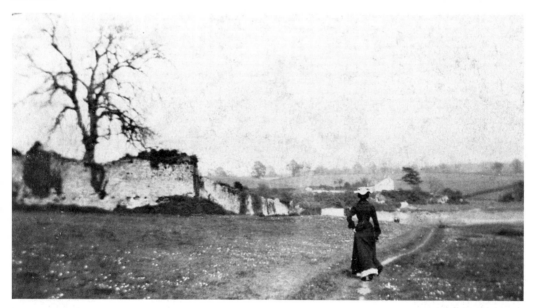

The stretch of the thirteenth-century Port-Wall that led down to the River Wye and was destroyed in 1916 to make way for the building of the shipyards. The wall now ends on the edge of the quarry near the railway station – the railway had caused the first modern breach of the wall in 1846. The lady is taking the path known as 'Fisherman's Walk'.

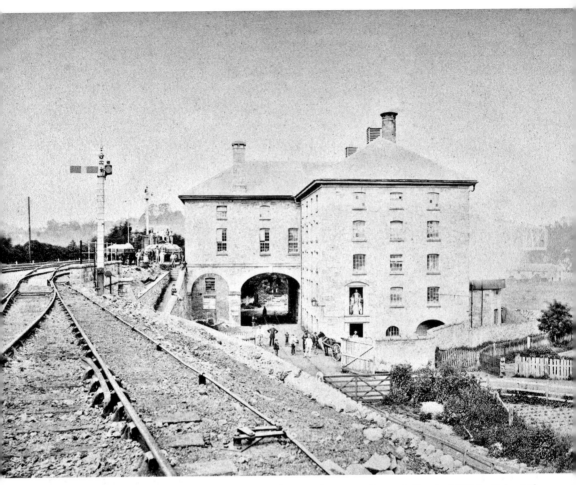

This large steam flour mill was built conveniently near the new railway station in 1851 by Robert Sharpe, railway contractor on Brunel's South Wales Railway. Initially in partnership with a Bristol cornfactor, a good trade was continued with Bristol for a few years. However, in 1858, after difficulties, the mill was offered for sale. It took five years to find new owners, Parnall & Co. of Newport. In the early 1890s it was turned into a malthouse (see added buildings below) by the Cardiff Malting Co. It supplied large quantities of malt to the big breweries in Burton-on-Trent as well as those locally. In the First World War the building was used by the Shipyard, for a while as a billet for Royal Engineers, and was part of the Yards, as its offices, for many years. Following a major fire it has been restored to that use by Fairfield-Mabey.

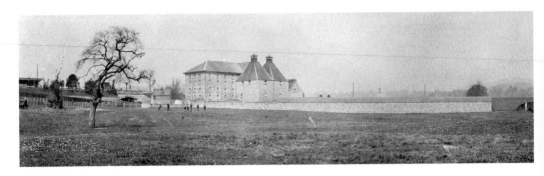

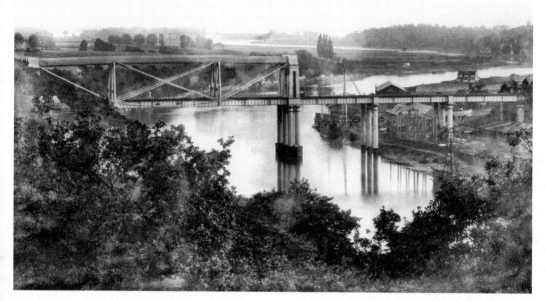

Brunel's Tubular Suspension Bridge over the River Wye opened in 1852, forming the vital link in the railway line that connected London to South Wales. The Wye crossing posed the railway company's engineer, Isambard Kingdom Brunel, major problems. Natural ones – like the rapid and high tides, a river bed with about 50 ft of mud before rock is reached and limestone cliffs on the Gloucestershire side, opposite a mudflat at low tide on the Monmouthshire side. In addition, the Admiralty insisted on a span of no less than 300 ft with 50 ft headroom above the highest-known tide so that shipping was not interfered with. Brunel solved the problems with a design typical of his inventive genius, this tubular suspension bridge. Across the main span of some 309 ft the railway decks were suspended from diagonal chains hung from two 9 ft diameter wrought-iron tubes. These rested on two masonry towers on the Gloucestershire side and corresponding towers of cast-iron plates supported by six cylinders in the river. The entire bridge was 600 ft long and had three other spans over the land and water supported on cast-iron cylinders. As well as bringing visitors to Chepstow by rail, the bridge itself became one of the attractions of the area because of its great size, height and unusual design. It also brought new industry to the town. Edward Finch, in partnership with his brother-in-law Thomas Willey, came from Liverpool to carry out the contract for the ironwork of the bridge and its construction. Willey died before the bridge's completion and Edward Finch stayed on at the site he had established for the contract right by the bridge. Bridge building is continued today in Chepstow by Fairfield-Mabey on the site which grew out of Edward Finch's Bridge Works and, in 1987, they built the new road bridge over the Wye alongside the rail.

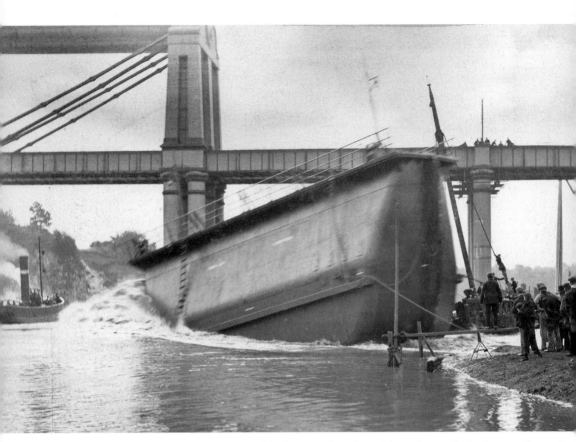

Launch of a Caisson into the Wye from Finch's slipway. Edward Finch's Bridge Works built wrought- and cast-iron bridges in the shadow of the Tubular Bridge, as well as producing dock gates, caissons, steam-boilers, gasometers, steam-engines and Finch's own patent iron-masts and spars for ships. The portly man in the top hat inspecting work (below) is James Rowe, the managing director of the company after Edward Finch's death in 1873. He had served his apprenticeship at Finch's as an engineer, and continued as manager until 1911.

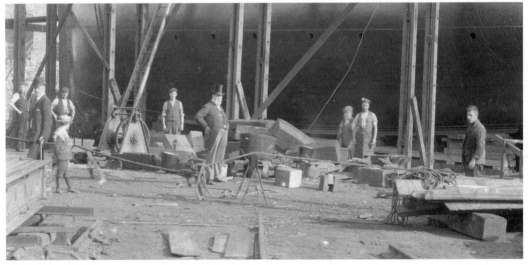

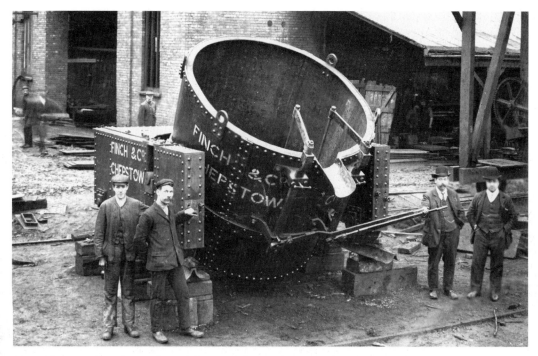

Above: The proud producers, but product and destination are unknown.

Below: St Mary's Hill Bridge to be erected near Newbury Station, built for GWR, 1908

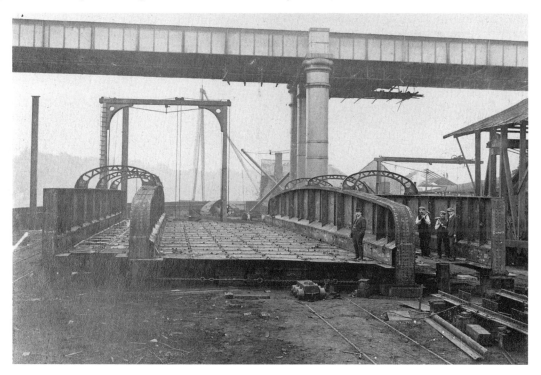

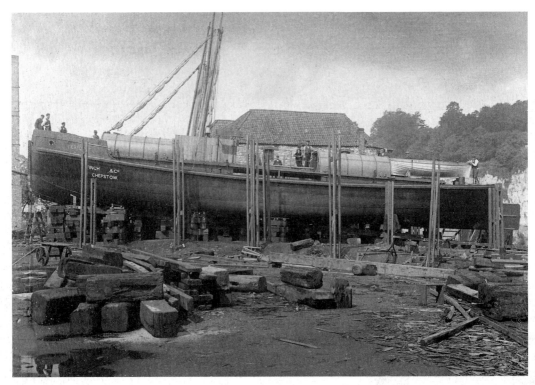

Finch & Co. had been building smaller vessels, tugs, barges and lighters, since 1879 and continued to do so into the 1900s. Here are the vessels *Periquito* (above) on the stocks and the *Marreca* (below) being launched from Finch's slipway, *c.* 1908.

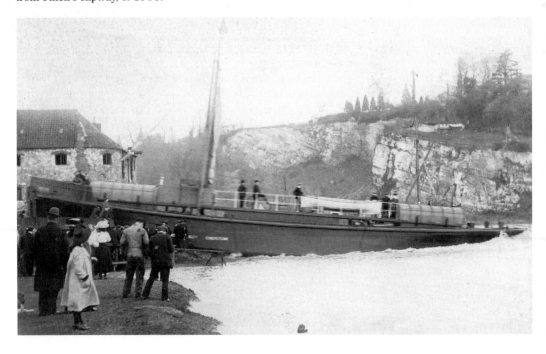

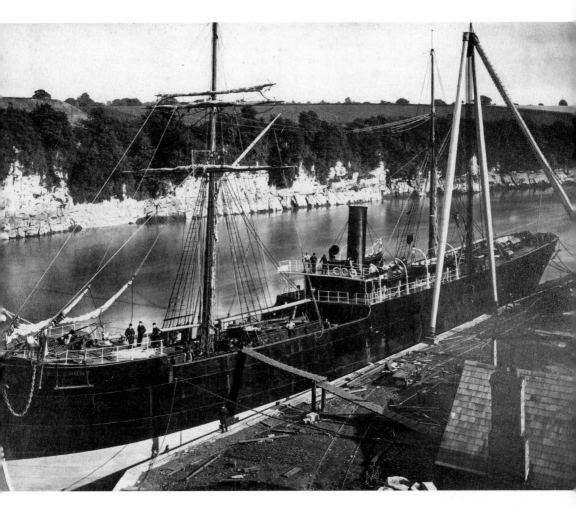

The steamship *Rougemont* (1,525 tons gross), the first big ship built by E. Finch & Co., was launched in 1882 and is seen here at the fitting out jetty. The launch was a great event. At 6 o'clock on the morning of 19 April a large crowd of spectators made their way to Tutshill cliffs for the best view and were lined along the top for half a mile, a thousand more gathered on the river bank near the yard in the misty rain to watch Miss Rowe, the manager's daughter, launch Chepstow's largest-ever steamer – up to that time. There followed an intense, but it seems brief, period of building ships of this scale, the largest being the SS *Arrow* in 1884, which was the biggest then to have been built in South Wales. Finch's manager, James Rowe, followed the fortunes of his first big ship with interest, receiving letters from the chief engineer who wrote enthusiastically about the *Rougemont*'s performance. During one fearful gale 'the ship behaved *more* than splendidly rising over each sea like a bird and (not like the rest of your Jarrow built tubs) not *vibrating* in the slightest degree ...'. The life of the *Rougemont* however was relatively short. Built for John Cory & Sons, colliery proprietors of Cardiff, she was struck in dense fog off Elsinore in June 1893 while carrying coal from Blyth to Stockholm and was damaged so badly that she sank.

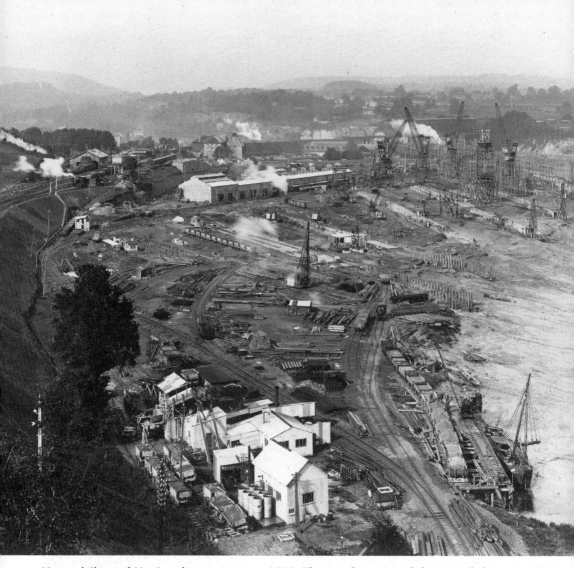

National Shipyard No. 1 under construction, 1918. The transformation of the riverside began in 1916 when the Standard Shipbuilding Company was formed by a group including Lord Inchcape and J.H. Silley, marine engineer, who had served his apprenticeship at Finch's. Its aim was to build some of the 'standard ships' which were being mass produced to standard designs in shipyards around the country to rapidly replace the heavy losses that British merchant shipping was suffering from German submarines. The Standard Shipbuilding Co. established a yard adjoining Finch's and planned to lay down eight slipways for building ships up to 600 ft long. However, in August 1917 the Government took over the project as part of a grand scheme to create three National Shipyards centred on the Wye and Severn – No. 1 at Chepstow, No. 2 at Beachley and No. 3 at Portbury. Nationalization was to enable the rapid construction of the yards by using military and prisoner-of-war labour.

Opposite above and below: Royal Engineers working on the construction of National Shipyard No. 1.

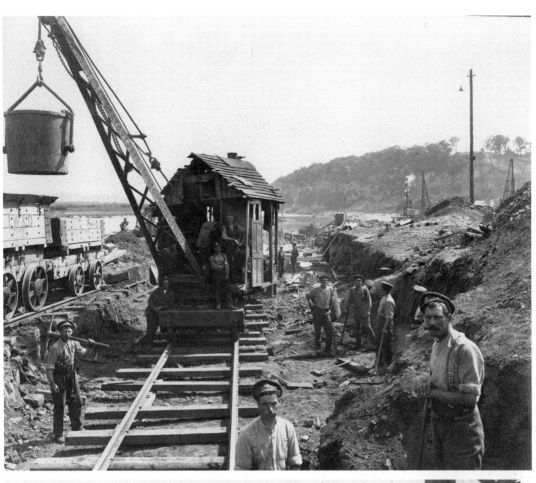

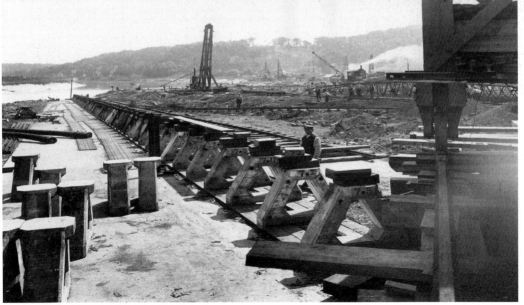

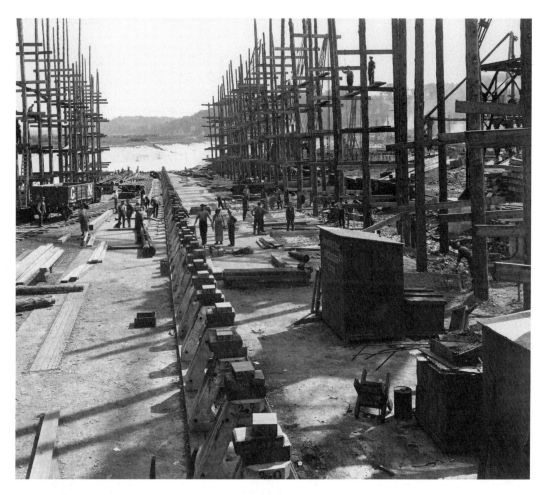

A completed slipway ready to receive the keel of its first ship. To speed ship production, the National Shipyards were to be used to build pre-fabricated ships. All existing shipyards were working to capacity, so bridge building yards inland were brought into use to manufacture the component parts up to a size and weight that could be transported by rail to the National Shipyards for assembly. Sections of the keel of the first ship arrived at Chepstow in April 1918 and by this time two berths were ready. However, progress seemed slow and the project was criticized for poor organization. The Nationalization scheme was disliked not only by private shipbuilders but also by shipyard workers who objected to the possible use of military labour in the construction of ships. Meanwhile in Finch's yard standard ships were being built. It had become a subsidiary of the Standard Shipbuilding Co. in 1916, with John Silley its chairman, but in August 1918 it was incorporated by the Admiralty into the National Shipyard. The next month, the *War Forest*, built in Finch's yard, became the first standard ship to be launched from the National Shipyard No. 1. When the war came to an end, not a single pre-fabricated ship had been produced. Work was continued on a reduced scale under the Shipping Controller until a buyer was found for National Shipyard No. 1, in a new consortium, the Monmouth Shipbuilding Company. The ambitious scheme under Nationalization, which cost over £6 million, was regarded by many critics as a Government failure.

Opposite above: Pre-fabricated 'N' type (National Type) ship under construction, April 1919.

Opposite below: View of stern casting and aft end of No. 3 ship (*War Odyssey*), July 1919.

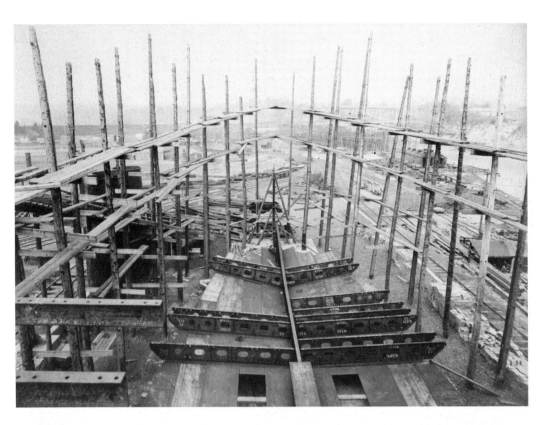

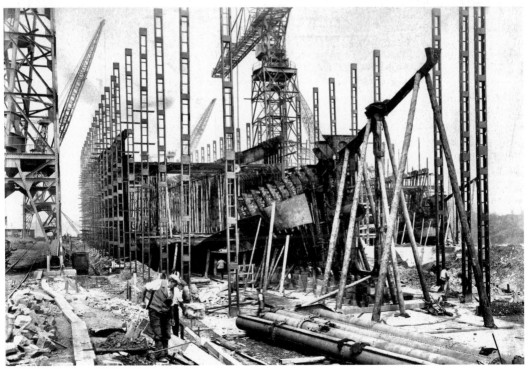

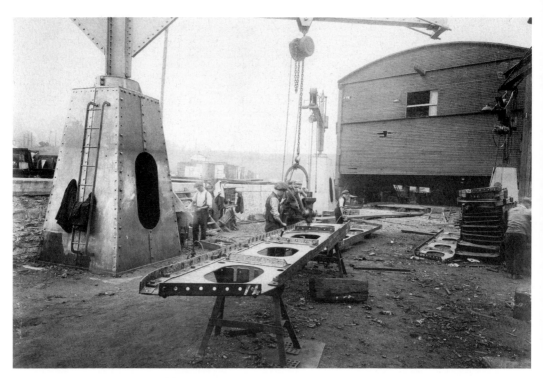

Men working in Finch's yard which, although nationalized, continued in the 'old working methods' of pre pre-fabrication. *Above*: riveting plates. *Below*: inside the framing shed.

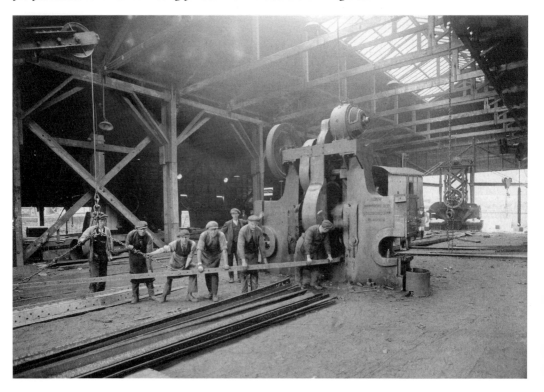

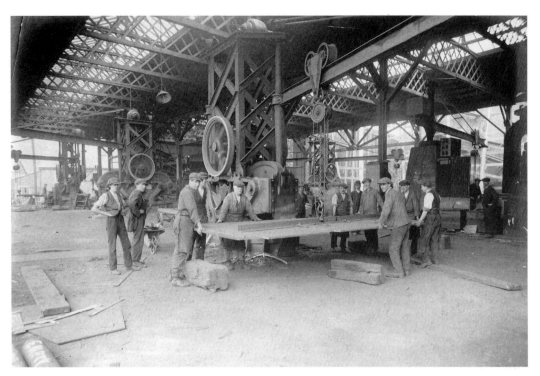

Inside the Plating Shed showing the shearing and punching machine. Holding the plate, left to right: Bob Andrews, -?-, Geo Davies. Right of machine, left to right: Harry Brown, -?-, David 'Novice' Davies, -?-, -?-, -?-. All three photographs were taken on 18 September 1919.

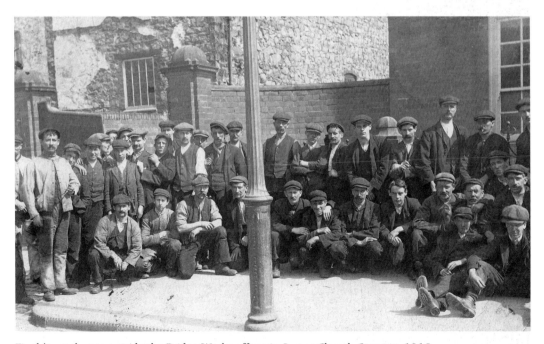

Finch's employees outside the Bridge Works offices in Lower Church Street, *c.* 1918.

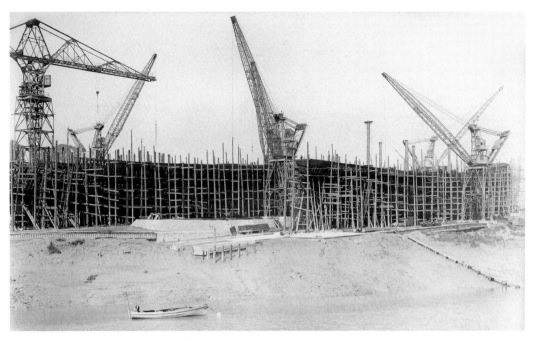

View from the river of the fabricated ships being built in National Shipyard No. 1, 8 September 1919.

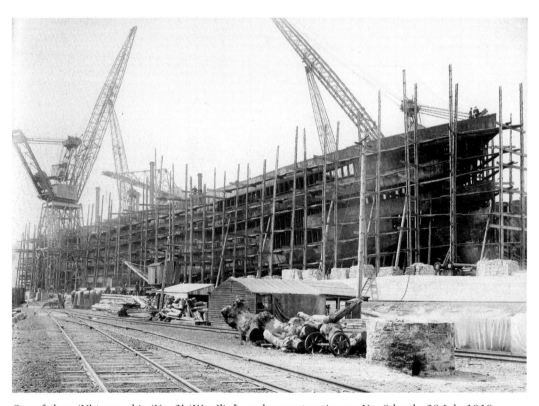

One of these 'N' types, ship 'No. 2' (*War Iliad*), under construction on No. 8 berth, 28 July 1919.

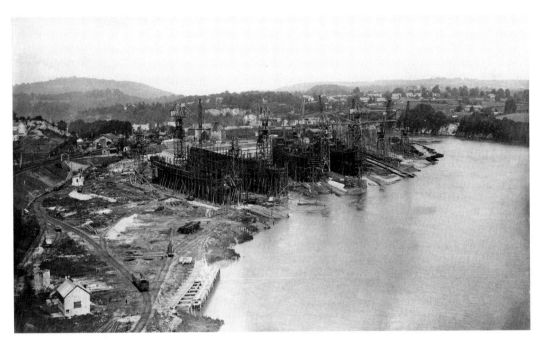

View of the main 'South Yard' with ship building at about the time that National Shipyard No. 1 was bought by the Monmouth Shipbuilding Co., early 1920.

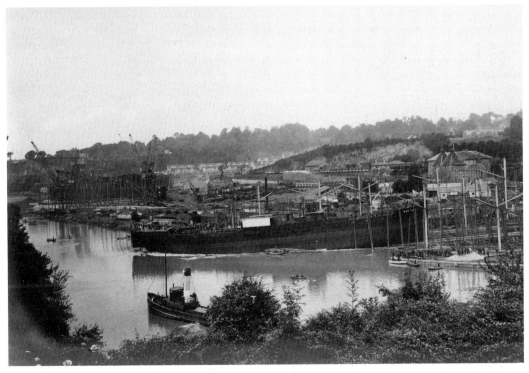

Launch of the *War Fig*, 17 August 1920, from the 'North Yard' (ex E. Finch & Co. (1916) Ltd), one of the standard ships built in that yard.

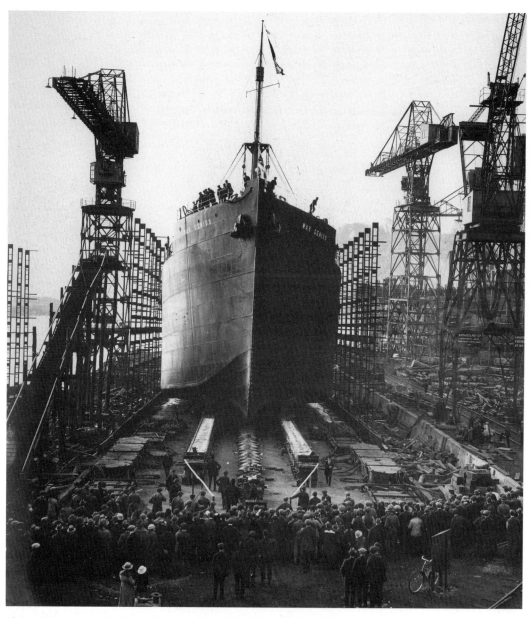

Three of the six pre-fabricated 'N' type ships completed and launched by the Monmouth Shipbuilding Co.

Above: The *War Genius* slides down the slipway, 30 October 1920.

Opposite above: The *War Glory*, first of the 'N' types to be launched, 21 April 1920, a much photographed and well-remembered occasion witnessed by thousands. At 10.05 a.m. a tense silence preceded the signal to Lady Maclay, wife of the Shipping Controller, who performed the ceremony to three rousing cheers. Within 67 seconds of moving, the ship was fully waterborne. Several tugs were in attendance and their whistles shrieked as the *War Glory* itself hooted triumphantly. The ship was fitted complete with engines and ready for service. Despite the optimism of that day, the yard was closed three years later.

Opposite below: The *War Odyssey* being towed down the Wye. It was built and launched from Chepstow's yard, 30 September 1920.

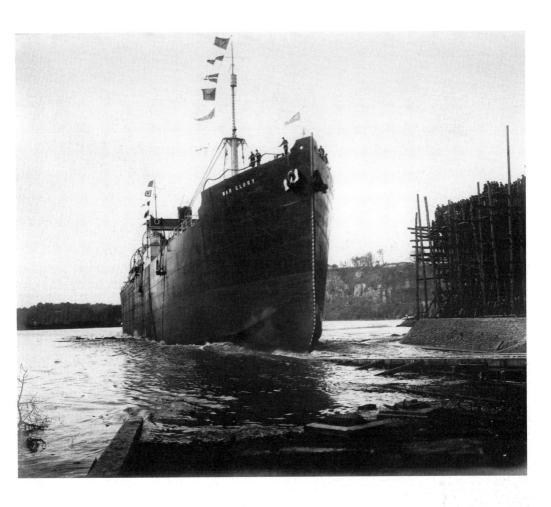

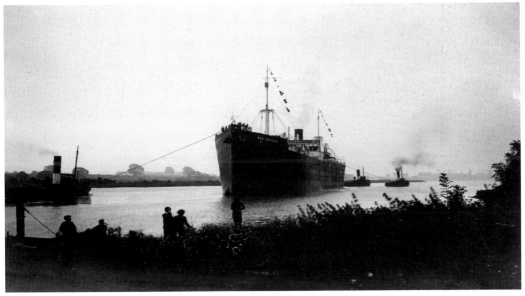

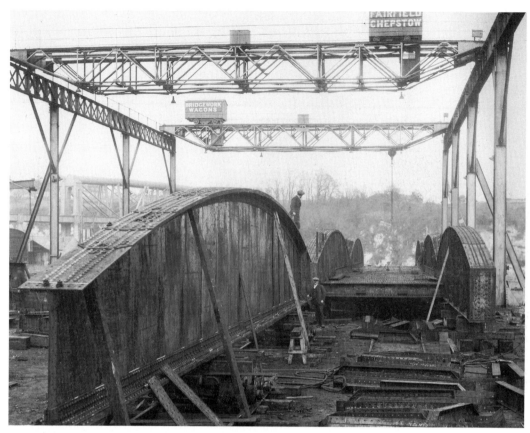

Above: Bridge spans being assembled in Fairfield Shipbuilding & Engineering Co.'s yard, late 1920s. E.J. Price, plater (on the ground); Tom Kirton (above).

Below: Launch of Tank Landing Craft (Mark 8) designed for Pacific service, in 1945.

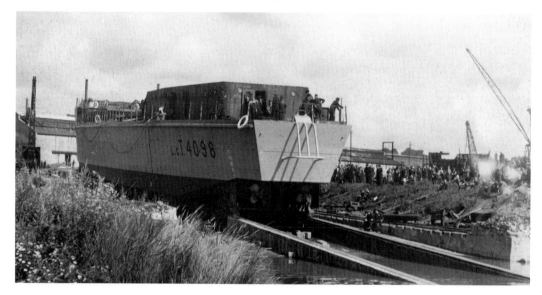

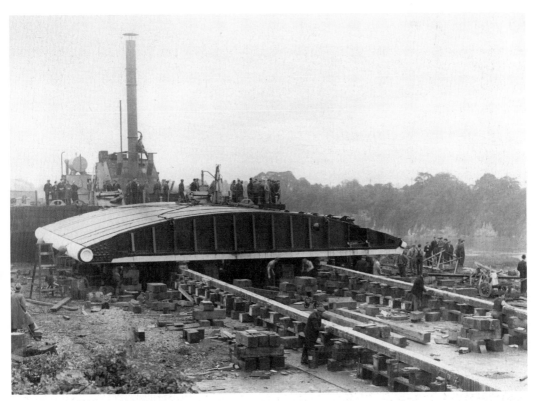

Above: Dock gate for GWR Kings Dock Lock, Swansea, about to be launched with pontoon for a 60 ton floating crane in the background. Fairfield Shipbuilding & Engineering Co. took over the yards in 1925 and concentrated its general engineering work at Chepstow. Here they built railway wagons, steel-framed buildings, bridges, etc. During the Second World War over 60 tank-landing craft, pre-fabricated at inland workshops, were assembled, launched and fitted out at Chepstow (see below). Many were used at the D-Day landings, two were for the Far East.

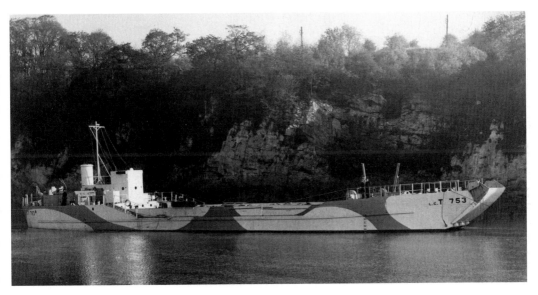

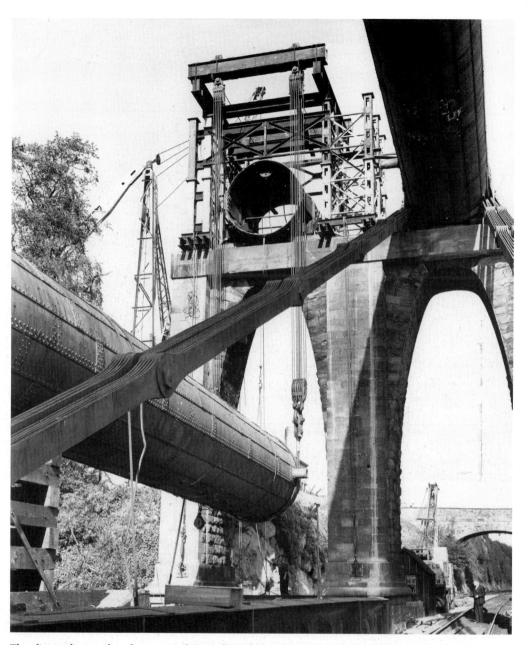

The dismantling and replacement of Brunel's Tubular Suspension Bridge was carried out by Fairfield Shipbuilding & Engineering Co. for British Railways in 1962, 110 years after their predecessor Edward Finch had celebrated its opening. Trains had been restricted to 15 mph for a long time and excessive stresses in the structure, as well as the need for increased use of the railway, caused British Railways to scrap Brunel's bridge.

Opposite below: Shows one new span in place and, behind, the other being winched across the river hanging below the far span of Brunel's bridge. Once the new span was in place it was possible to cut the tubes and lower them onto bogies (see above).

Opposite above: Replacing the girders of the approach spans in 1948.

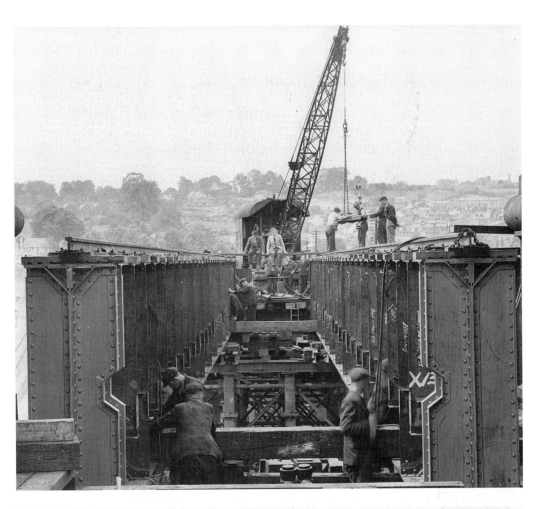

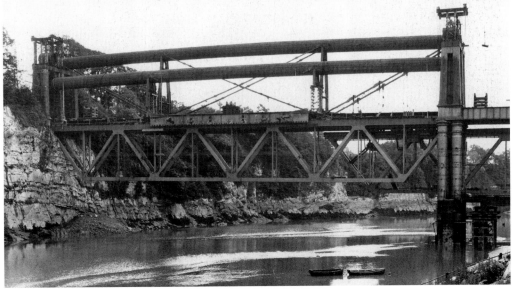

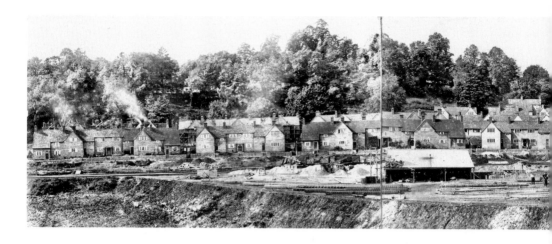

Above: Panoramic view of the 'Garden City' at Hardwick under construction. The new shipyards required an influx of skilled workers, many of whom were to come from the north-east and Scotland, and would need housing. In 1916 the Standard Shipbuilding Co. aimed to provide better social conditions for workmen by giving them good surroundings along the lines established by the influential 'Garden City' movement, with comfortable and attractive houses in a planned landscape amid beautiful countryside, away from the demoralizing urban slums. The architects of the Hardwick housing scheme were William Dunn and W. Curtis Green. On the sloping site, side-streets, following the general contours, were laid out from the central road, Hardwick Avenue. Three open spaces were proposed, one as a village green with trees, the others for tennis, bowls and a recreation ground. The houses were designed for various classes of workmen – labourers, skilled tradesmen, foremen and clerical staff, and given 'appropriate' variety in the size and quality of accommodation (the largest were for the foremen). There were no standard designs, each block of cottages being planned to suit its uneven site and prospect, though only a limited number of types of doors, windows, stairs and chimneys were used. The houses were built of concrete blocks made with two machines on site.

The Standard Shipbuilding Co.'s plans were curtailed by Nationalization. Although concrete hut accommodation for the soldiers was constructed, the house building programme was virtually neglected for nearly a year. It was resumed when the housing crisis became so acute that progress at the National

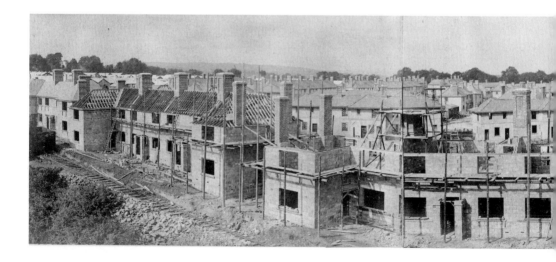

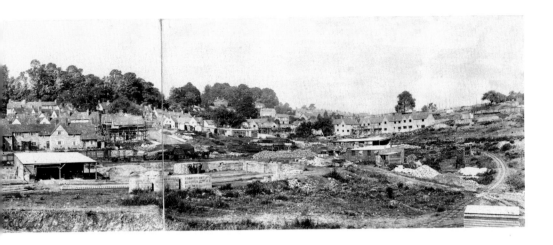

Shipyards was hampered by the lack of skilled workers. Hardwick was continued, Bulwark and Pennsylvania in Sedbury were started and German prisoners of war were employed in the making of all the concrete blocks. A notable local resident, Henry Avray Tipping, an advocate of town planning, garden designer and an authority on architecture, was involved in an honorary capacity overlooking the plans in conjunction with the Admiralty architects. However, the first Bulwark houses, nearing completion after 6 weeks work in September 1918, were met with an outcry of dismay and horror 'pigsties and dog kennels' – their small size outraged the council. Concessions were won from the Admiralty who agreed to alter about 20 of the 42 smallest type houses. The Bulwark houses were built to standard designs but the larger ones and the overall plan met with general approval.

Below: Panoramic view of Bulwark garden suburb under construction.

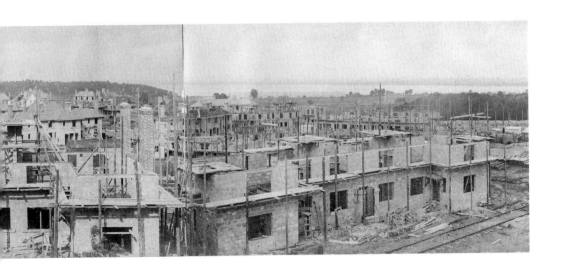

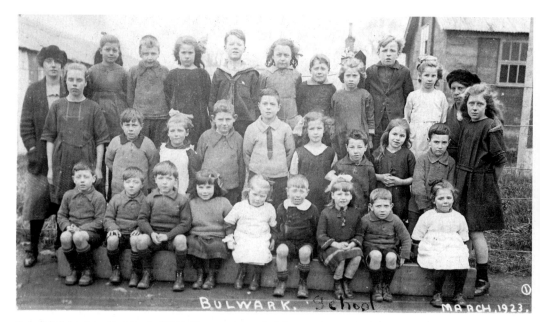

Bulwark School pupils, March 1923. There was much debate early in 1920 about the need for a school in the Bulwark area where the new housing was increasing the population. It was decided that summer to convert one of the many concrete huts, which had been built between Bulwark road and the Hardwick cliffs initially to house the military, Royal Engineers working on the construction of the National Shipyards and later shipyard workers.

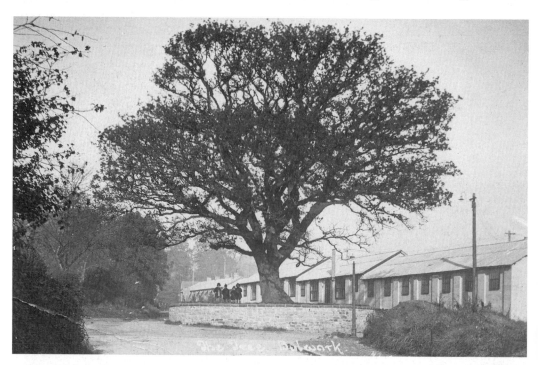

A Bulwark landmark was 'The Tree' which stood in the centre of the junction of Bulwark Road with the beginning of the 'garden city' development. Behind, some of the concrete huts of Bulwark camp can be seen in this photo taken in 1920.

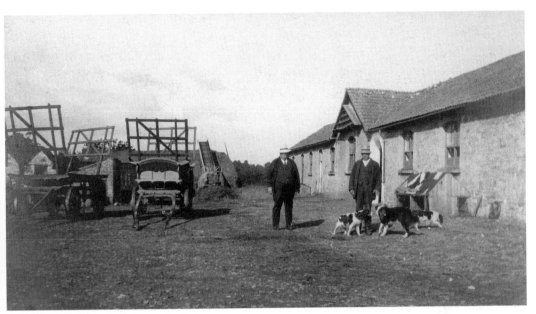

Only the name of Newhouse Farm is now preserved by the motorway roundabout and warehousing development on its site. It was one of the old established farms of the area, like its neighbouring Thornwell and Claypits. The Langham family were farmers at Newhouse from the early 1880s. *Above*: Charles Langham (right) photographed with his dogs and friend Tommy Mastin on the 'Pitchin' in August 1926. Behind him are the stables. The specks on the roof are doves perched above the dovecote in the gable. *Below*: John Langham (right) with his cousin John Stracey, both aged 12, in the small rickyard at the farm in 1910. The boys cut the hay, made the rick and thatched it themselves. No doubt they refreshed themselves from the cider jar, bottom left, with the farm's own cider.

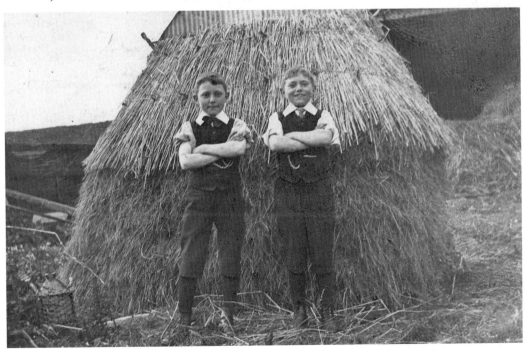

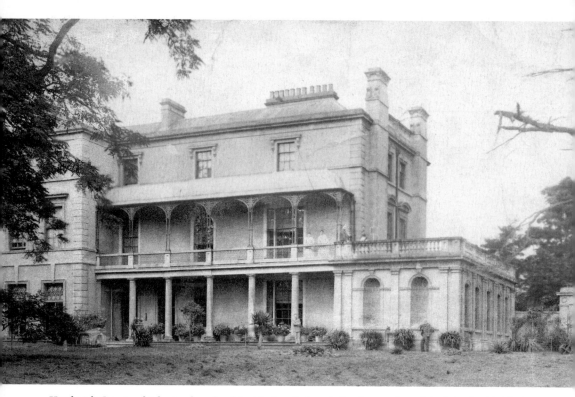

Hardwick Court, which stood on land just below Bulwark Road, was demolished in the 1960s. In 1808 Charles Heath wrote, 'In point of situation it may vie with Persfield' (Piercefield) but regretted that the 'intended additions to this house remain unfinished'. Hardwick House, as it was known, was at that time owned by Thomas Fydell, MP for Boston, Lincs. The colonnade, however, was designed for a later distinguished owner of the house, Edward Copleston, Bishop of Llandaff, who lived here from 1836 until his death in 1849. Bishop Copleston was largely responsible for the 1841 alterations to the parish church, work which the restorations of the 1890s and early 1900s sought largely to reverse.

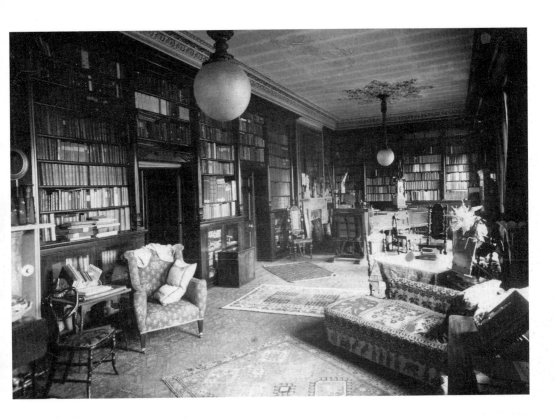

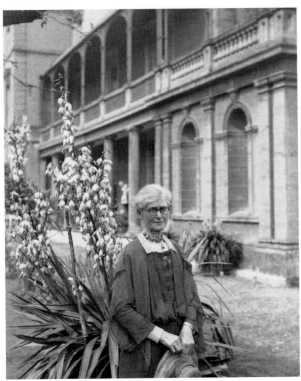

Above: The Library at Hardwick Court in around 1925. Two fine libraries were successively housed on the floor-to-ceiling shelving. One belonged to John Fitchett Marsh, who as town clerk of Warrington was instrumental in establishing the first municipal library there. He retired to Hardwick Court in 1873 and began researching the history of Monmouthshire castles but only finished the Chepstow section by his death in 1880. It was later published as the *Annals of Chepstow Castle*. His own library was auctioned at Sotheby's in 1882. The next resident, Ernest Hartland, FSA, a solicitor in Cheltenham also had an extensive and important library. The photograph, left, of Mrs Hartland outside Hardwick Court was taken in August 1936 when she presented 2,000 Bibles and 1,500 rare books including thirty-two incunabula (the earliest printed books of the fifteenth century) to the John Rylands Library in Manchester in memory of her late husband.

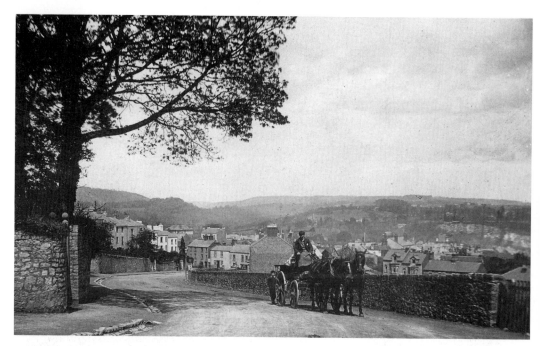

Mount Pleasant was created in the early-nineteenth century. Steep Street was the way out of town to Newport until 1808 when it was decided to build this new road 'for easing the hill' at the Green Dragon Turnpike Gate.

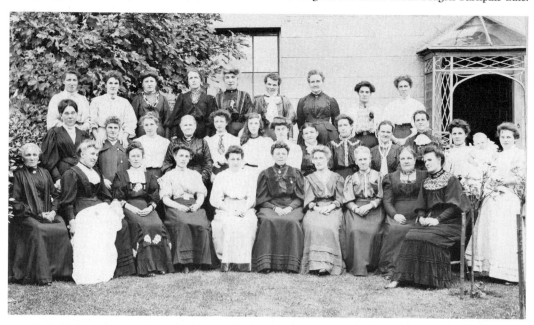

Members of the Baptists' Sisters' meeting assembled in the front garden of this house on Hardwick Hill in 1908. The organization was formed by Mrs Connor (front row, sixth from left) during the pastorate of her husband, the Revd John Connor, who died in 1907. Back row, left to right: Mrs Vincent, Gibbs, Mills, Mabel Jones, Dade, Ranford, Downey, Goat, -?-, Middle row: Childs, Greene, Bigham, -?-, W. Hobbs, Margaret Connor, -?-, Miss Fowler, Watkins, Priscilla Powell, Fox, Annie Powell, Ursula Powell. Front row: -?-, -?-, Griffiths, Monico, C.J. Cole, Connor, Miss Phillips, Pardoe, F. Fox, Brown.

Hardwick Hill House was built in the early-nineteenth century. One of its notable inhabitants (from *c.* 1850–64) was the second Baron du Bois de Ferrieres whose collection of Dutch and

Belgian seventeenth- and nineteenth-century paintings was given to Cheltenham Art Gallery in 1898 by his son, an eminent citizen there. The third Baron also commemorated his father's 20-year residence in Chepstow with the gift of the stained glass east window in the parish church when the chancel was restored in 1896. Hardwick Hill House is best remembered as Oakfield Preparatory School. This was begun and run for 42 years, by Miss Nightingale, pictured right on her wedding day. Although married for nearly 50 years she remained 'Miss Nightingale' to her many pupils. Mabel Rebecca Nightingale married John Bodenham, a professional gardener at some of the big houses in the area including Itton Court, Shirenewton Hall and Mounton House. In around 1970 the school was sold and they retired to Oakfield Bungalow on the Newport Road, which had been built originally as the school premises and then converted to living accommodation. Miss Nightingale died in 1977, aged 83, John Bodenham in 1979, aged 81.

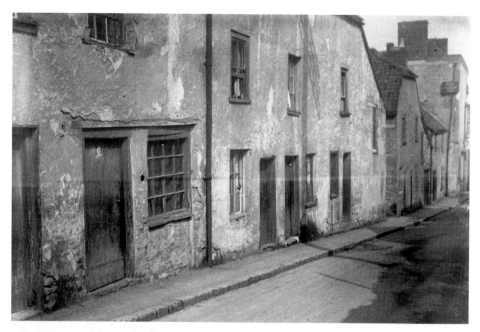

Thomas Street photographed just before its demolition.

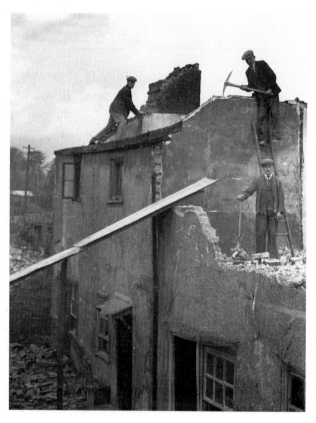

Easter Court, one of the courts of houses leading off it on the north side, in the process of demolition in April 1936. The street and its courts were swept away as part of a slum clearance scheme and its inhabitants were rehoused, many reluctantly, in new council houses built at St Tecla, Bulwark, in 1935. At the bottom of Thomas Street at the far right of the above photograph, was the Rose and Crown, otherwise known as the Bomb and Dagger because of the suspected 'revolutionary tendencies' of its locals. It escaped demolition until 1984, having closed 10 years earlier.

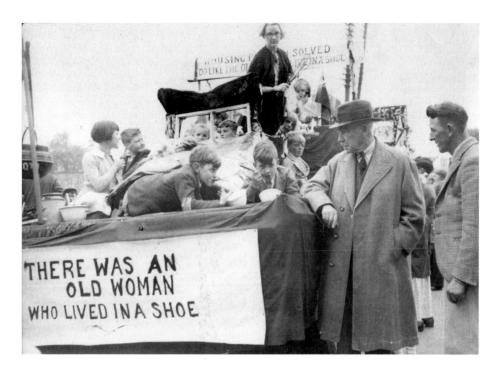

'Housing problem solved. Do like the old woman live in a shoe' was the topical comment on the current rehousing programmes on the top banner of this float in the coronation carnival, 12 May 1937. Councillor Walter Clifford Thomas takes a stern view! *Below*: the float carrying Queen Elizabeth and her court (see page 23).

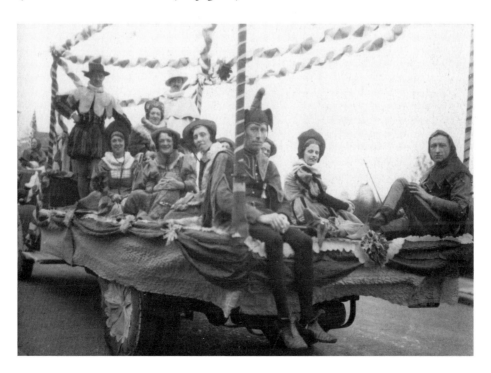

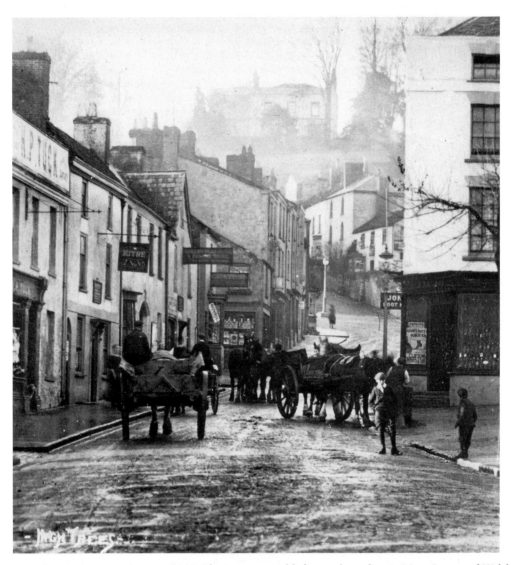

A wintry view up Moor Street, *c.* 1910. There were monthly livestock markets in Moor Street and Welsh Street in Victorian times, until the opening of the cattle market, hence a large number of inns in Moor Street. Two close neighbours seen here were The Mitre and The Queens Head. The property in between, a court of houses behind, and The Mitre, were demolished and the police station built there during 1912. On the left, Harold Powell Tuck opened his butcher's shop here in March 1907 as 'purveyor of First Class English meat only'. Above The Queens Head, the sign and window with Bovril advertisement belonged to G. Griffiths, grocer at No. 12. The corner-shop window above was another grocer's, E.G. Mills, at No. 9. On the right is part of Albion House and the Albion Boot Stores of James Thomas. Just around the corner is the sign for E. Jones who was a boot and shoe maker at No. 28. The view continues up Steep Street where the first building was the Pine Apple Inn. On top of the hill through the mists is High Trees, originally called Belle Vue. It was renamed in 1889 by George Dewdney who opened the Chepstow Boys Grammar School here in 1871. After his death in 1905 the house was sold. Mr & Mrs Cooke-Taylor were the resident owners at this time.

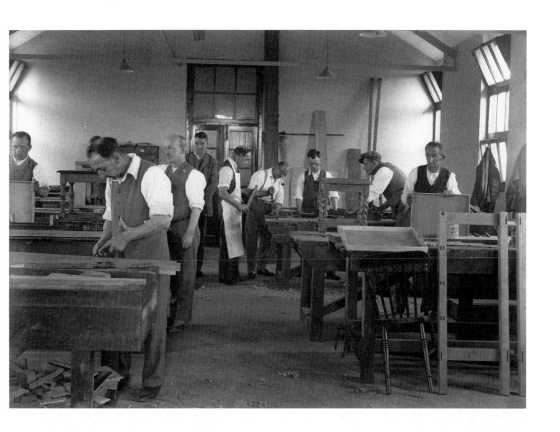

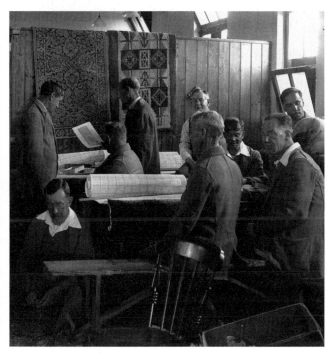

War Pensioners, affectionately known as 'Boys in Blue' from their regulation blue uniforms, in the workshops at Mount Pleasant Hospital. These photographs, showing the men making and mending furniture, basket and rug making, were taken on 24 June 1938. The hospital was built by the Admiralty specifically for workers in the National Shipyards. Begun in January 1918 and opened in November of that year, it was transferred to the Ministry of Pensions in April 1919 after the Admiralty ceased control of the Shipyard.

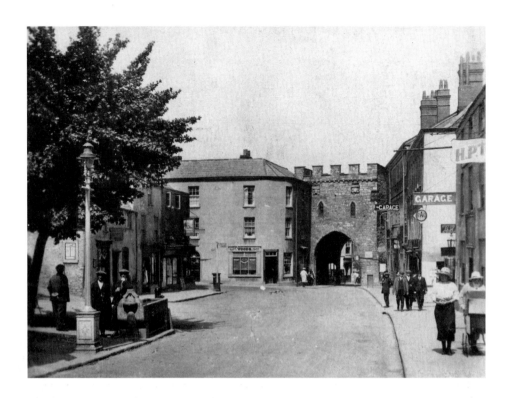

Two views down Moor Street in the early 1920s.

Above: On the corner of Albion Square the horse trough, becoming redundant in the light of the number of garage signs! The first indicates the presence of the Greyhound Garage in the yard of the Greyhound Inn, which started in around 1908 as the Chepstow Motor Garage Co. The other sign on the George indicates Hanbury's Garage in Welsh Street. On the corner of Welsh Street Mrs Margaret Woods kept a confectionery shop.

Right: The old lady stands in front of the bay window of No. 12 (Griffiths grocers p. 66) where there is a sign for the receiving office of Winfields Hygienic Laundry. Next door, at The Queens Head, Allen Dibden was the proprietor.

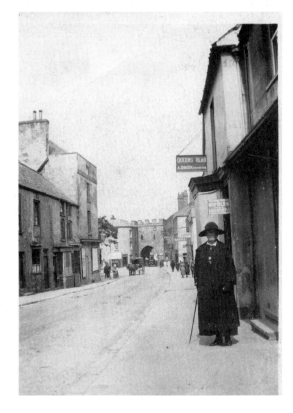

A carthorse being led up Moor Street close to the entrance to the farrier's yard. The sign for J.B. Dobbs' shoeing forge can be seen on the side of the building, No. 17, The Greyhound Inn. The forge was in a yard at the back. The shop being passed by, No. 18, was Robert Waugh & Son's music and piano sellers. John Bennett Dobbs was a blacksmith and farrier in Chepstow from around 1870. His business was continued by J.H. Cavill, as manager in the 1900s, then under his own name from 1910. The photograph below may be J.B. Dobbs' forge but does not show Mr Cavill. Positive identifications are welcomed.

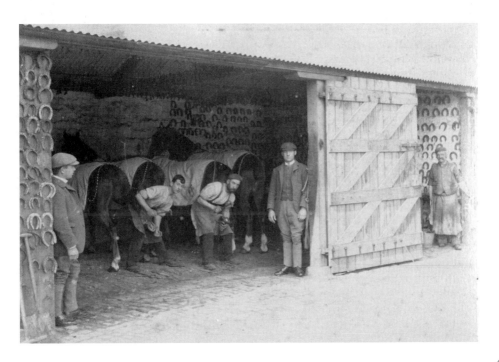

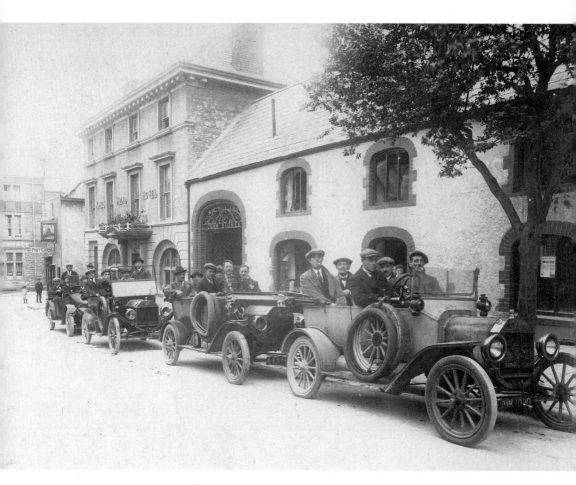

An outing about to leave from outside the Kings Head Hotel in Welsh Street in the early 1920s. The Kings Head was completely rebuilt in its present form in 1907 following a totally devastating fire. No damage was done to the adjoining property, Mullins' corn stores. A.E. Mullins opened a branch establishment here in 1896 of the corn, seed, cake and manure business that the family had been running for the last 20 years from the Corn Stores warehouse at The Back. The Welsh Street premises had previously been used as a malthouse by J. Chappell and Mullins had alterations made to the building in 1898. Sacks can be seen in the upper floor and the notice in the window is from the Chepstow Water Company regarding a shortage of water. Back on the corner of Welsh Street, the hanging sign advertises the Wye Not Café which was on the first floor.

Opposite above: Heading up Welsh Street, past the Congregational Chapel, the Coach and Horses and the Cedars, on the way to the races, *c.* 1912. At that time the races were held at Oakgrove, St Arvans, the home of Henry Hastings Clay. It had been the venue for one-day meetings since the 1860s but, aided and greatly abetted by Walter Smedley, Clay developed courses, stands and paddocks and, through the 1890s, raised the standard of racing and prize money so that Chepstow's two-day meeting became the premier fixture in Wales and the West Midlands.

Opposite below: Side by side in Welsh Street stood St Mary's Roman Catholic Church (right) and the Beulah Congregational Chapel. Both were demolished in 1972 when a through road to the car park was made. The Congregational Chapel was built in 1834 by a group which had broken away from the strict Baptist church in Chepstow 10 years earlier.

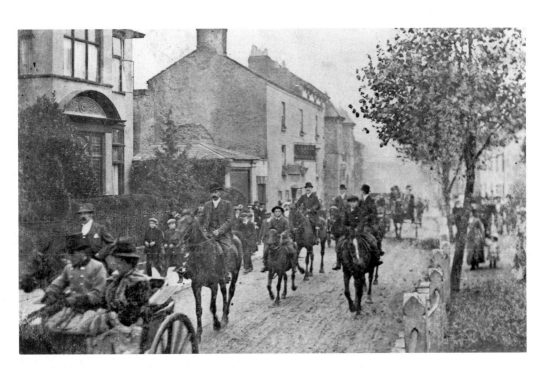

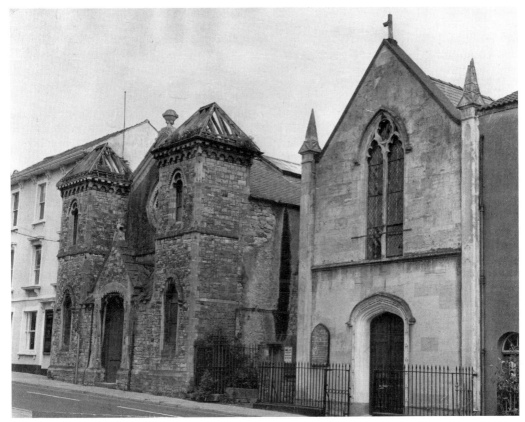

St Maur College in Welsh Street was purpose-built as a school for young ladies and opened in April 1895. It was considered remarkable for the 245,000 bricks used in its construction but its patterned brickwork is now obscured by stucco and paint. The building was converted into flats after the Second World War. It was called St Maur after the house at No. 8 Beaufort

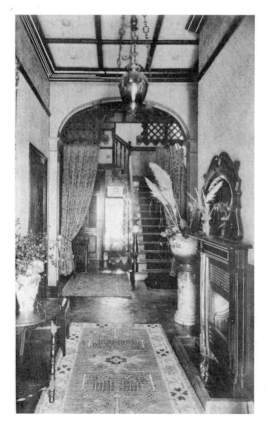

Square where the Misses Thomas had been running a ladies' seminary. Mary Thomas began the school in the late 1870s at No. 5 St Mary Street where her mother had the Golden 5 grocery stores. In 1885 she and her sister moved into the more spacious premises in Beaufort Square. Mary's marriage in 1890 to the Revd J. Hale Stephens, minister of the Congregational Chapel, did not interrupt the sisters' teaching careers and they continued as co-principals of the school, first in Beaufort Square, and then in Welsh Street. The photographs on both pages illustrated the prospectus for St Maur College under the principalship of Mrs Glyn Nicholas in the late 1920s. Much importance was given to the beautiful situation of the school, the local climate to which was attributed 'life-preserving qualities' and the school's own 'lofty and well-ventilated rooms'. Boarders experienced the life of a 'happy British home'.

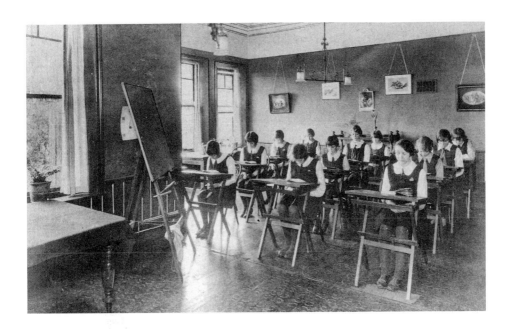

A schoolroom at St Maur. The principle of small classes was strictly maintained. Pupils were prepared for the Oxford Senior Local, London Matriculation, etc., but public examinations were not compulsory. The subjects taught were scripture, all branches of English, mathematics, geography, science, botany, history, class-drawing, class-singing, French, needlework, handcraft and domestic science – a photograph of the latter class is shown below. The aim of the school was 'to develop the character, intellect and healthy growth of the child for the good of the community; to encourage self-expression, to increase resource and initiative by practical work'.

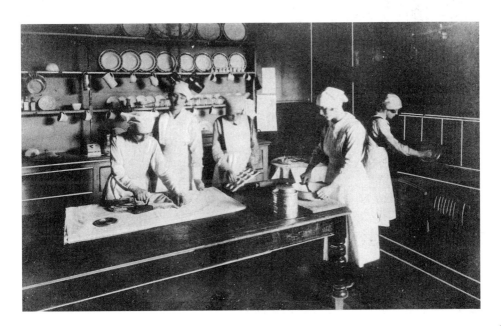

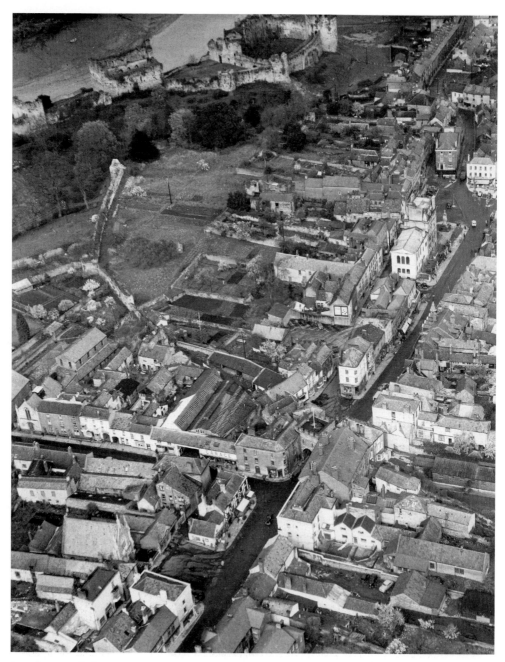

Aerial views of Chepstow town centre, above and left, *c.* 1950. An area that has since seen drastic change is Welsh Street, where premises not only fronting the street but behind it back to the Portwall have been replaced by new buildings, including a supermarket and the access road to the town's main car park – which covers land occupied here by orchards and allotments. The Portwall was also breached to make way for the access road. The redevelopment of Thomas Street with a supermarket and shopping mall swept away buildings in the bottom left corner of the picture. Right of the Town Gate can be seen the wooden Public Hall in the grounds of the Gate House, that was replaced by the Senior Citizens Centre. Gone too are the Old Bank and Bank Buildings, replaced by Barclays Bank.

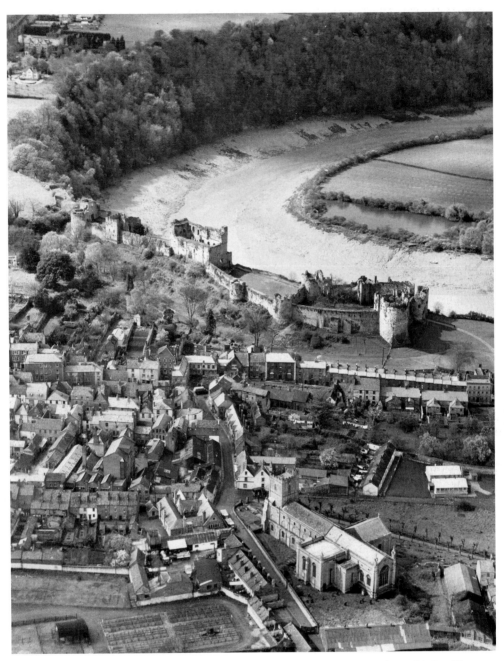

The Priory, the area bounded by Lower Nelson Street and the church, with market, school and houses, has been a car park since the 1970s but changed again with landscaping and access to the extension of the inner relief road the A48, in the late 1980s. Also replaced by the road, at the rear of the church is the old Church Boys House, latterly known as St Mary's Institute. The area between St Mary Street and Lower Nelson Street has been altered by demolition as well as shopping and pub redevelopments. At the top of Bridge Street the Davis Court flats have replaced an earlier Davies Court of houses, two public houses and the old Palace cinema. Looking beyond the churchyard two canteen buildings are the sole occupiers of open land and garden which is now Hollins Close housing.

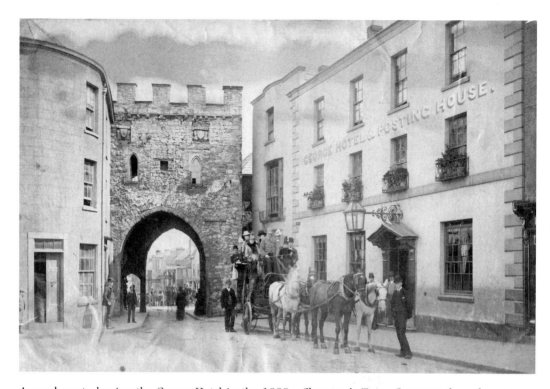

A coach party leaving the George Hotel in the 1880s. Chepstow's Town Gate was the only entrance through the Portwall on the landward side. The present structure dates largely from the early-sixteenth century, when the room above was used as a prison. It had been a tailor's workshop when this photograph was taken and, in 1949, became the first home of Chepstow Museum. By the little arch market tolls were collected until 1874. However, the junction of Moor Street and Welsh Street was also the site of Chepstow's alternative market cross known as Robin Hood's Cross, presumably because the lord was being 'robbed' of his market dues. The cross became a traffic obstruction for carriages and was dismantled in 1759, its large stones being re-used for milestones. The George was one of the town's principal coaching inns in the early-nineteenth century. It was also one of the oldest of Chepstow's inns. Margaret Cleyton, whose vivid memorial is in the parish church, built the George in around 1620. Her initials are carved above the doorway of the Gate House (see opposite) and her two properties may have had an underground connection – a tunnel was discovered during the rebuilding of the George in 1899. The George seen in the photograph was destroyed by fire in May 1896. Despite the efforts of the Volunteer Fire Brigade, which were hampered initially by an inadequate water supply, the building was completely gutted, with only the main walls left standing, although the billiard room and some outbuildings were left intact. The site of the George was sold that August at auction for £975. Plans for the new George were drawn up, but there was a delay before their realization and the hotel was not completed until 1899.

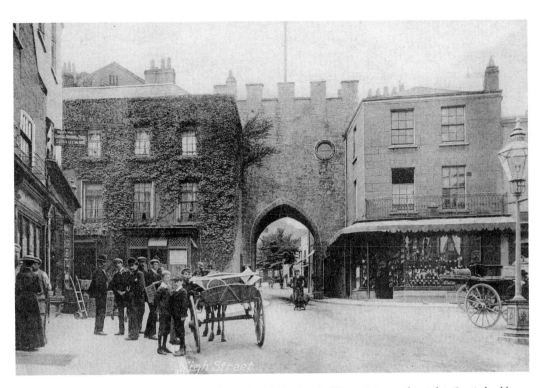

The Town Gate and top of High Street in the early 1900s. By the Town Gate on the right, Curtis had been selling boots and shoes in this shop from the early 1880s and before that from No. 27 High Street. In 1882, the first year of advertising at these premises, C. Curtis had 'Boots of all descriptions to suit everyone, which will be sold at the lowest possible prices for ready money' and the following year, tailoring to another market perhaps, added a bespoke department for the manufacturing of handsewn boots to measure at moderate prices. Curtis' shoe shop by the Town Gate was to last for nigh on a century. Since Margaret Cleyton rebuilt the Gate House in 1609, it has been a home, as well as being used for a variety of purposes including a surgery, brewery and banks. At the time of this photograph it was occupied by the Metropolitan Bank of England & Wales. In 1919 it was the property of the London City & Midland Bank, who agreed to sell it for £3,000 and donated £500 towards its acquisition. The rest was paid by J.H. Silley, who then presented his purchase to the town. A native of Chepstow, he was the man who brought the Standard Shipbuilding Co. here. The gift of the Gate House was also originally intended to be a war memorial, with the names of Chepstow's fallen inscribed on it, but that function was later fulfilled by the cenotaph. After internal alterations the Gate House became the Urban District Council's offices and the significant external change – the cutting of the pedestrian passage – was made in 1928. The shopfronts on the left belonged to Woodgate's corn and flour merchants at No. 4, and above Edwin Ellis' grocery stores which were continued by H. Thomas & Son, of the Golden 5 stores.

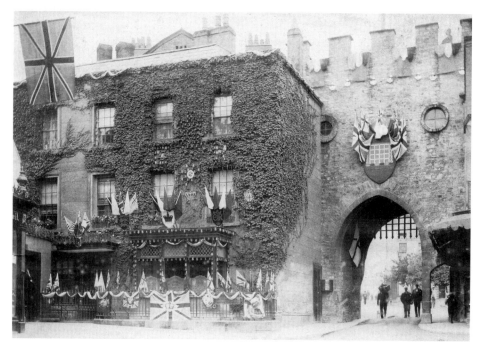

For Edward VII's Coronation, 9 August 1902, the Town Gate decorations included fake portcullis and dummy sentries on the battlements. The Metropolitan Bank of England and Wales at the Gate House was lit up at night – note the fairy lights around their etched windows.

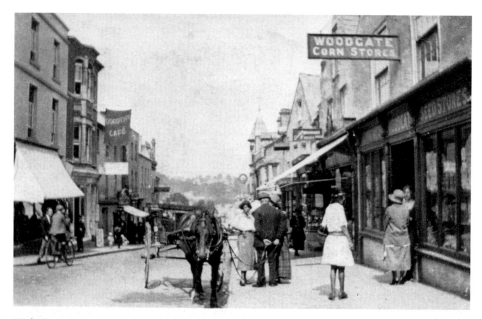

High Street view, from by Woodgate's at No. 4, 1920s. The Dorothy Café banner marks the restaurant and boarding house run by Mrs Curtis. Curtis & Curtis were outfitters next door up.

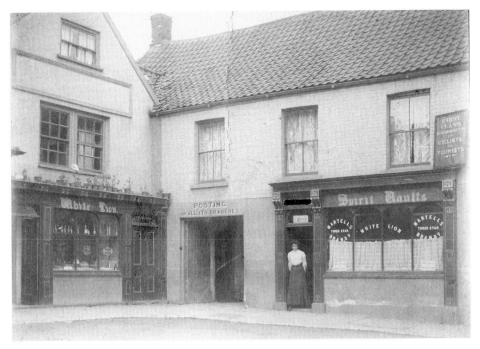

The White Lion dates from the early-seventeenth century when it was known as the House at Pye Corner, and later as the Magpie, making it one of Chepstow's oldest inns.

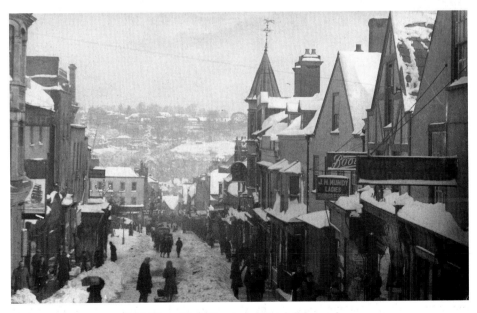

The notorious snows of 1947 on High Street and Tutshill beyond.

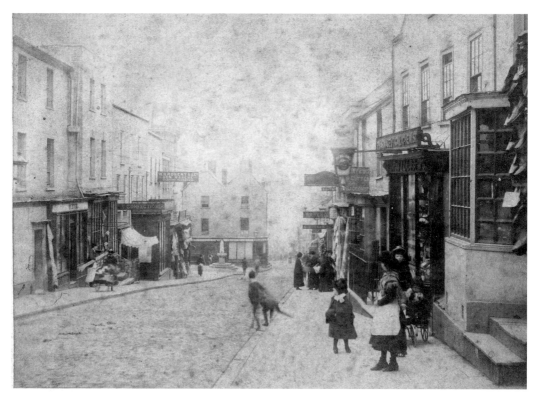

Looking down High Street, *c.* 1885, visible about as far as Bank Square. Notice the goods arrayed outside shops and that many still have small-paned windows. On the left, at No. 28 was Benjamin Dexter, grocer, tea and coffee dealer. Next door James Thorneloe Horniblow kept 'The Original Clothing Stores'. The sign for the confectioner advertised William Williams at No. 26a who was a grocer, baker and pastry-cook, and made 'rich bride cakes to order on shortest notice'. The prominent shop front at No. 26 belonged to Alfred Hillman, printer, bookbinder, bookseller and stationer, and in the toy, wool and fancy repository he and his wife Ellen stocked all manner of novelties, medicinal remedies, tea, tobacco ... At the next door down the display of carcasses belonged to butcher, Edwin Hurcum, and the projecting sign can be seen, although no more is visible of W.H. Roberts' Bon Marche Drapery Warehouse at No. 24. Back across the road, on the near right, are the shoe displays of Thomas Harris at No. 5. Nos 6, 7 & 8 can be seen face on, on the facing page. In the above view, No. 7 is well signed for William Francis Williams pharmaceutical chemist who proudly advertised his own unfailing remedy for coughs, colds, hoarseness and influenza – 'Williams' Compound Pectoral Oxymel of Horehound'.

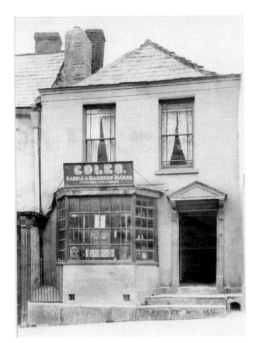

Left: Coles' Saddlers and Harness Makers, No. 6, advertised their business as established over a century, in around 1910. John Coles was certainly here from *c.*1844 and his daughter Margaret Ellen Coles continued the business until 1920. From the mid 1920s the shop was occupied by chemists for some 40 years, over half of that period by Boots. The premises were completely rebuilt by the Gas Board in 1965 for showrooms that closed 30 years later.

Right: When Gullifords occupied the shop at No. 7. John Gulliford, watch and clock maker and repairer and stockist of jewellery, cutlery, spectacles etc. advertised his move to these premises in July 1894. His son William carried on the business until 1945. The house was occupied at this time by the Joliffe family who were well-known professionally as accountants.

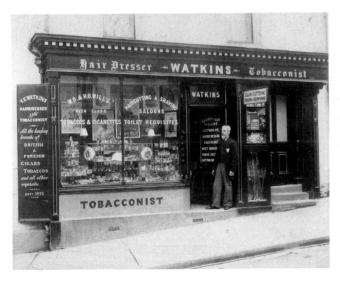

Valentine Edward Watkins stands in the doorway of his hairdressing and tobacconist shop, No. 8, a family concern that was continued until 1979. V.E. Watkins established his business in 1871 but at the top of Bank Street, near The White Lion. This shop front has remained essentially unchanged.

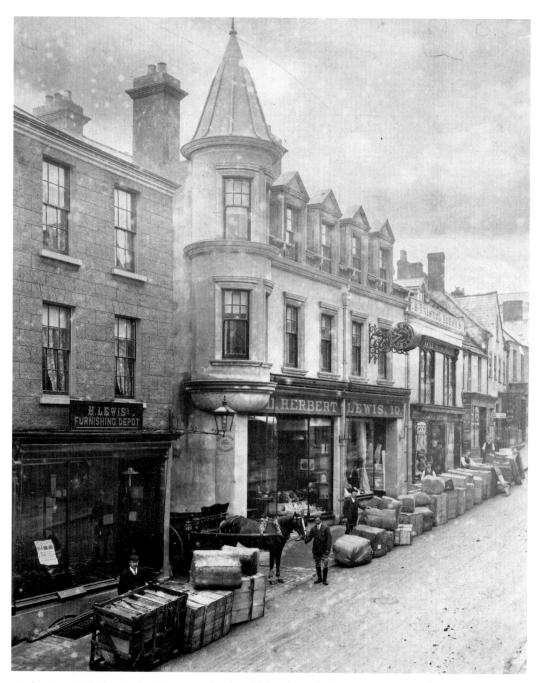

Herbert Lewis' distinctive building, completed in 1902, was called Coronation Buildings to commemorate the crowning of Edward VII that year. At a public meeting to discuss putting a clock on the Town Gate to mark the royal event, Herbert Lewis, seeing nothing was to be done, announced that he would put up a clock on his new building. The clock became the firm's trademark. Herbert Lewis started with just one shop, No. 9, which he leased when he came to Chepstow in 1878. He called this drapery shop the Bristol House because he had served his apprenticeship there. Gradually he expanded the business, buying Nos 11 and 12 High Street in 1882 and later leasing No. 10.

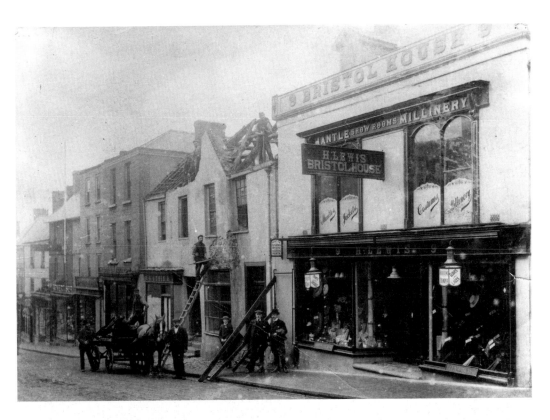

Above: The sale of the Duke of Beaufort's properties in 1899 enabled him to purchase his original premises at No. 9, but it took a few more frustrating years before he was able to buy No. 10. Within a few months Herbert Lewis began demolition of both 10 & 11 to create his new building, although the premises remained individual shops until 1959. As he had acquired space so he had enlarged his range of merchandise and the staff to deal with it. His three children helped: Alice with drapery and fashions, Ethel with china and glass and Bert with furniture. Alice married J.R. Griffith and members of the Griffith family continue to run the store today.

Left: Herbert Lewis.

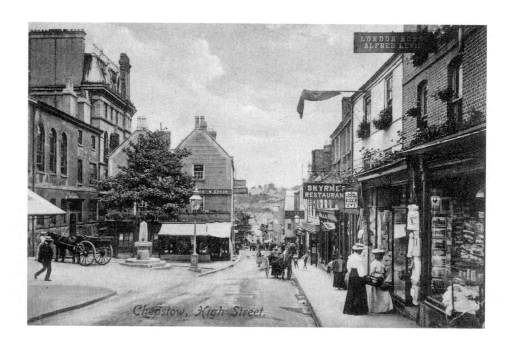

Above: Looking down High Street almost from the corner of Bank Square *c.* 1909. An early casualty to increasing road traffic was the island block of buildings – fronting Bank Square, High Street and Beaufort Square and making Bank Avenue – that created a narrow point in High Street. Demolished in March 1919, with it went the 1878 granite drinking fountain, a memorial to Revd Thomas Jennings, a former curate of Chepstow, paid for by his daughter. The fate of the fountain was resolved later in 1919 when it was agreed to move it to the top of the Castle Dell using £30 left over from the Dell opening celebrations fund raised in 1886!

Right: Miss Emmeline Clarke in front of her shop at No. 14 High Street. Her window is the nearest in the picture above. She and her brother, W.E.N. Clark, publisher of the *Chepstow Weekly Advertiser*, the local newspaper begun by their father in 1855, moved to this location in 1898. Miss Clark continued the stationery and bookselling side after the printing business was sold.

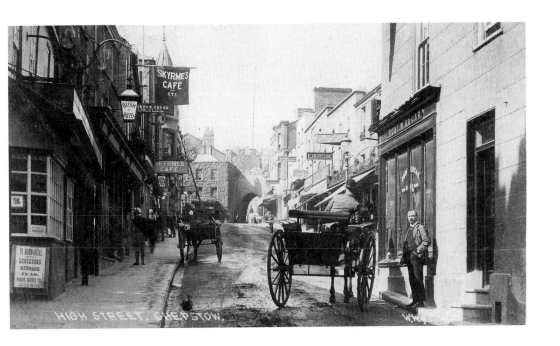

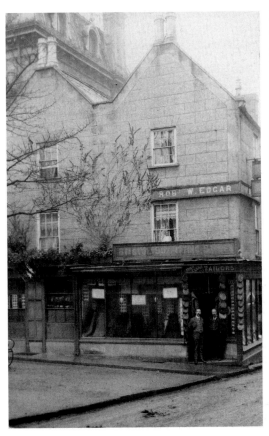

Looking up High Street from below Bank Square *c*. 1909. On the left, the Bush Hotel, its timber framework and wattle and daub construction of late-medieval or Tudor date was fully revealed during its demolition in 1964 to make way for a new store for Woolworth's. Outside No. 17 hangs the Golden Key (now in Chepstow Museum), sign and trademark since 1880 of Proctor's Iron Stores. The banner proclaims the presence at No. 16 of Howard Skyrme's Café, bakery and boarding house. The London House, seen opposite also, was a draper's shop run by Alfred Lewis, brother to Herbert. On the other side of High Street, E.H. Skyrme, brother to Howard, has the grocery store at No. 28. Robert Quinton has Alfred Hillman's printing business, although he retained the shop, and Willie Davies had a shoe shop at 26 too. Edwin Hurcum, butcher at No. 25, now has the Indian & China Tea Company as neighbour. Robert W. Edgar is seen standing outside his shop, the Bristol Outfitting Stores, in both photographs.

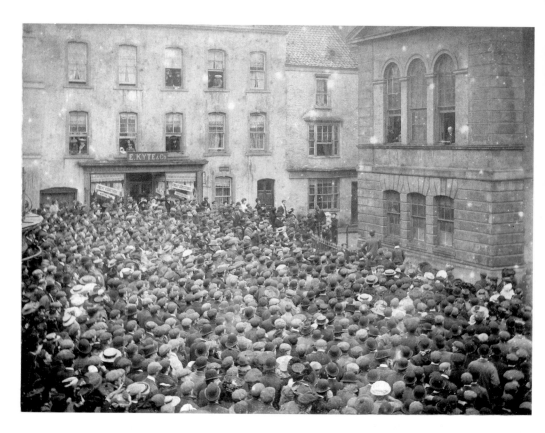

A large crowd gathered in Bank Square to hear an announcement being made from the first floor windows of the Bank Buildings, possibly the election results of the Urban District Council which held its meetings there. The large building facing the Square from Bank Street has a shop on part of its ground floor, occupied in the 1900s by E. Kyte & Co., 'Parisian and English milliners, ladies and children's outfitters', who were holding their January winter sale when this photograph was taken.

Robert W. Edgar moved his shop here after the sale of No. 22 High Street, where he had been since 1898, for its demolition in 1919. He eventually closed this shop in the late 1920s, and it was let to other businesses, but he and his daughter Verna continued to live there – they can both be seen in the first floor window of the house on the top photograph on p. 87.

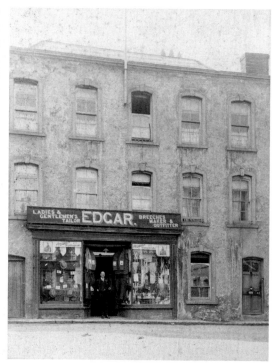

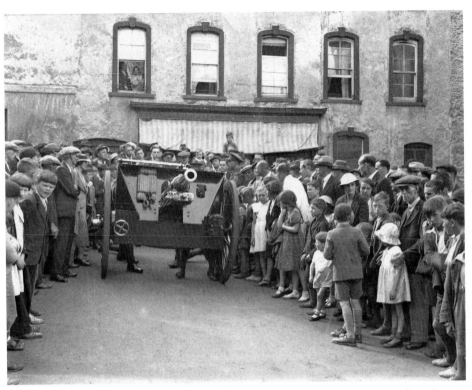

A working gun in Bank Square, and early radio sets outside Woodgates, High Street, attract the crowds in a recruiting drive on 2 July 1937.

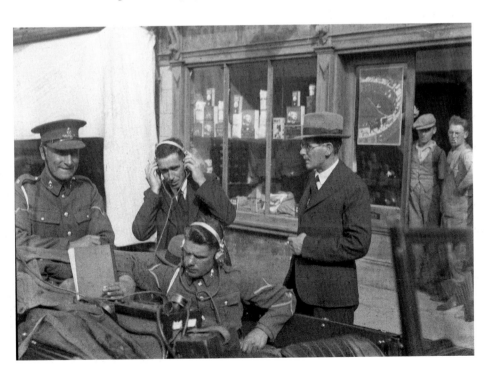

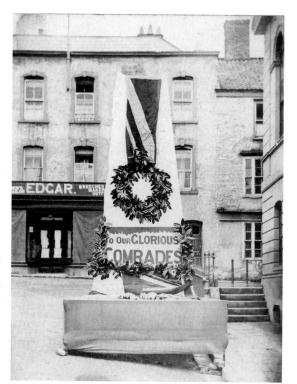

Bank Square was the site of a temporary war memorial in honour of the First World War dead. It was marched past on the occasion of Chepstow's Welcome Home celebrations in June 1920. The permanent stone monument in Beaufort Square was designed by Chepstow architect Eric Francis.

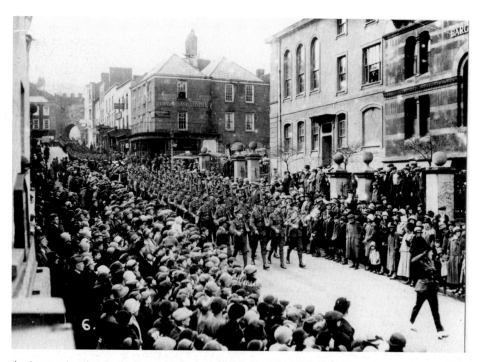

An impressive Armistice Day parade down High Street, 1920s.

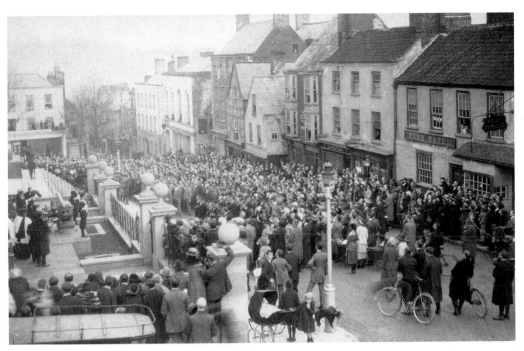

Crowds watched the unveiling of the War Memorials on 8 January 1922. *Above*: The Naval Gun presented by George V in honour of Able Seaman William C. Williams who was posthumously awarded the VC for his bravery at the Gallipoli landing. The gun, unveiled by Mrs Frances Smith, his eldest sister and next of kin, was installed in the new enclosure alongside the Bank Buildings. *Below*: The Chepstow cenotaph unveiled by Lieut.-Col. Evill.

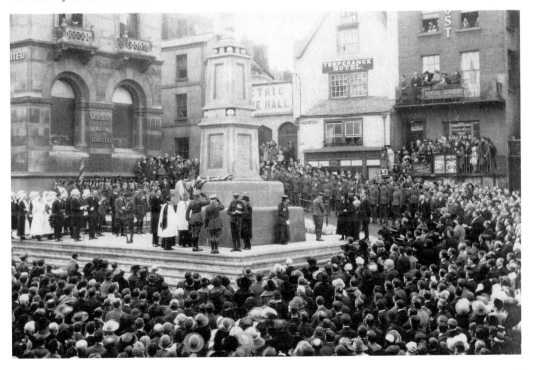

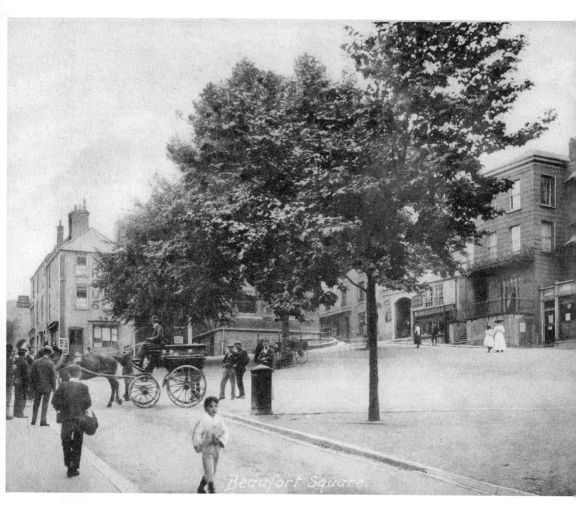

Beaufort Square

Beaufort Square, known for centuries simply as The Square, might not appear to justify the title today, carved up as it is by roads and terracing. However these photographs, above and top right particularly, show that it was indeed a large, open, if sloping, space. For centuries the square was the site of weekly markets and annual fairs. The town's importance as a trading place gave it its name from the early-fourteenth century (from the Old English, ceap – market, stow – place). Butchers' stalls or 'shambles' stood here, roughly on the site of the bank and war memorial, and The Square was alternatively known as The Beast Market in the late-eighteenth and early-nineteenth centuries. As well as a market cross, stocks and pillory were sited here. It was a central meeting place and, even in the early-twentieth century, it was still the focus for townspeople to celebrate, commemorate and hear important news. At times it has been a leafier place too. In the late seventeeth century a huge elm tree stood almost in the centre. Some of the trees in the photograph above suffered because they obscured the view of the bank. Certainly from the mid-nineteenth century it was the tall impressive bank that dominated Beaufort Square and the town's skyline. Built by Bromage Snead & Snead in 1850 for their Chepstow Old Bank, it housed successive banks, and their managers who lived on the upper floors, until its demolition in 1969. Built and demolished at the same time was the adjoining 'Bank Buildings' of Georgian style which housed magistrates and county courts in the nineteenth century. (See also page 86.)

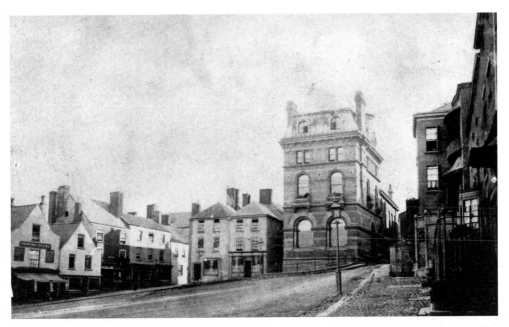

Above: c. 1870. Note that on the left, the building with a sign board, 'Printing Office', occupied by Thomas Griffiths, has not acquired its half-timbered appearance, which characterises it in later views. Next door but one, housing Nos 2 & 1 Beaufort Square, No. 1 was a chemist's shop, then run by Mrs Sarah Williams, and it continued as such for just over another century. There is a clear view of the bow-windowed block of buildings adjacent to the Bank. Its demolition in 1919 also removed the sense of enclosed space in the Square. Note the cobbling.

Below: When the War Memorial is in place *c.* 1922, and the post office is still here as is the Electric Picture Hall.

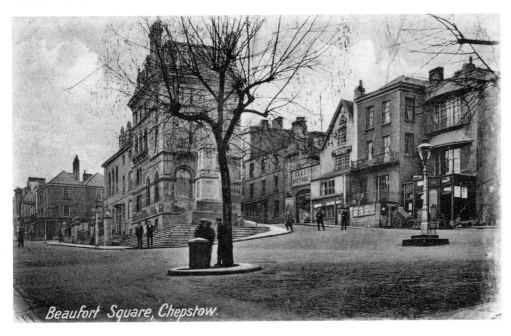

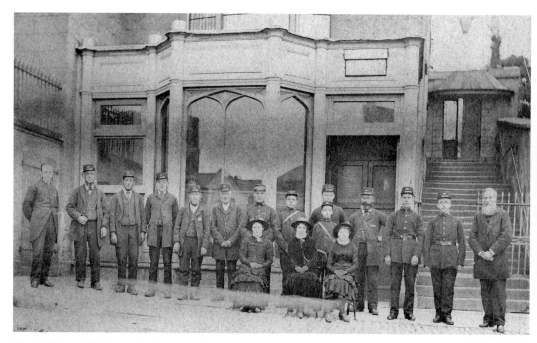

The staff assembled outside the Post Office in the ground floor of Raglan Lodge, No. 13 Beaufort Square, soon after the move there in 1880, when Frederick James became postmaster. Below, the interior showing the medieval vaulted roof which has faces among the carved stone detail. The fourteenth-century moot hall or meeting place of freemen of the borough may have been on this site. The room has had many uses including wine merchant's vault, coach house, armoury and, after the post office moved in 1923, as an antiques shop, the Food Office and latterly, beer cellar of the British Legion club.

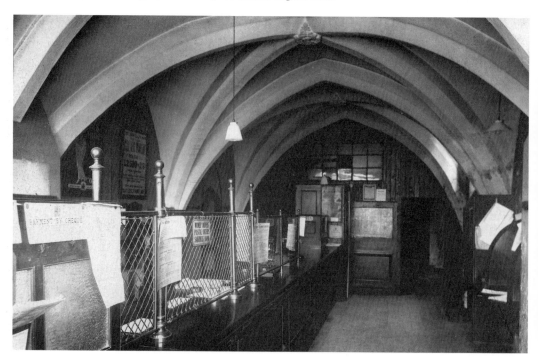

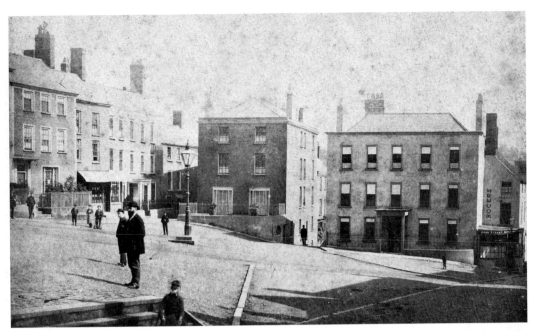

Above: Beaufort Square looking down hill, *c.* 1885, when the heart of the town still had significant private residences with no commercial use at ground floor level, as compared with the prospect below, late 1920s. The imposing No. 7, at the apex of St Mary's Street and Middle Street, was the home of Dr John Yeats, author, economist and philanthropist. Only after his death in 1902 was it converted into the shop premises of E.G. Walker, furnishing and ironmonger. The premises occupied by the National Westminster Bank since the 1920s were the home of banks before, in the early-nineteenth century, but reverted to private houses. Shaded by the canopy at No. 9 was G. Harris bakery shop which continued, run by Chepstow Farmers, until 1957.

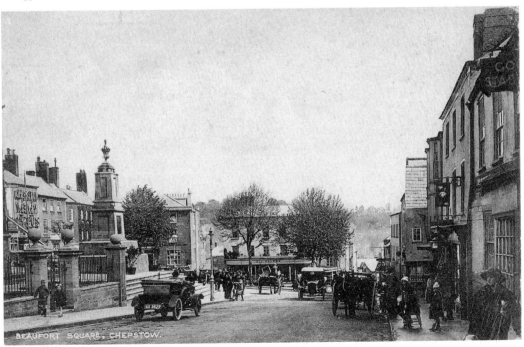

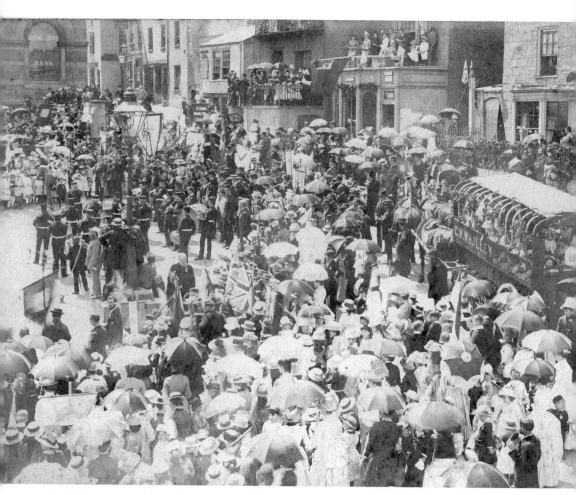

Beaufort Square has been witness to many momentous events and celebrations of local and national significance. Queen Victoria's Golden Jubilee was 'right royally celebrated in Chepstow' on 21 June 1887. After thanksgiving services a grand procession, led by the Band of the Gloucester Artillery, assembled in Mount Pleasant meadow and at 12 o'clock set off on a parade of the town ending in Beaufort Square. The procession included children from each of the various Sunday schools, formed up behind different coloured flags, as well as tradesmen, members of Friendly Societies and the Jubilee celebrations organizing committee. They lined the sides of Beaufort Square turning towards the centre where the band struck up the National Anthem which was 'heartily sung' and 'enthusiastic cheers given for Her Majesty'. Afterwards there was a free public dinner for the poor in the Market House to which various tradesmen contributed by subscription and in kind: meat and mustard, potatoes, bread and beer. Cuthbert Whalley, contractor and builder, donated a fat ox from his own farm, an act of generosity later rewarded by the presentation of the beast's head, preserved and mounted. He then lived at No. 14 Beaufort Square – a crowd is gathered on his railed balcony – and one of his furniture removal vans is in the picture. Chepstow photographers Tame & Ballard, it was later reported, 'were enabled to secure some capital photographs ... To those desiring to keep something in remembrance of the Jubilee these photographs afford a splendid opportunity for procuring most realistic mementoes.' This is one of two views they took, from different points, of the Assembly in Beaufort Square singing *God Save the Queen*.

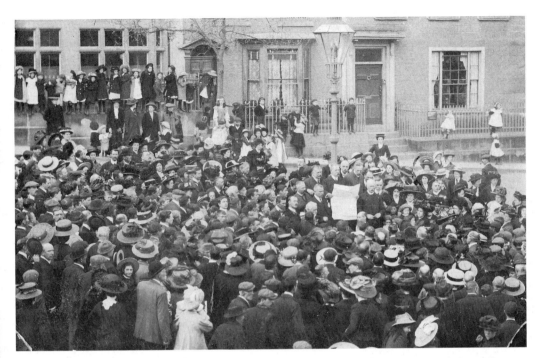

The proclamation of George V's accession to the throne in 1911 being read to the assembled crowd. Note, in the background, part of the facade of the London, City and Midland Bank, previously a double-fronted bay-windowed house (half of which is visible in the Jubilee photograph). Nos 10 and 11 were still private houses.

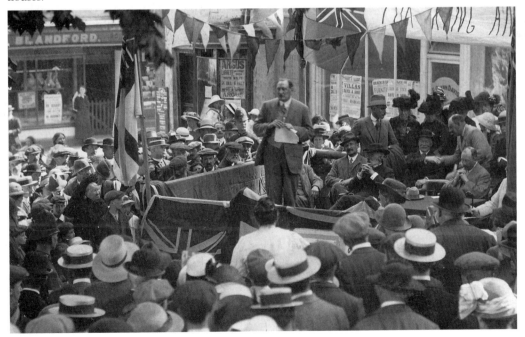

On the recruiting bandwagon 'For King and Country' in front of the Argus and Davis' offices in the block adjacent to the bank. Blandford's, the butcher, at No. 20 High Street can also be seen.

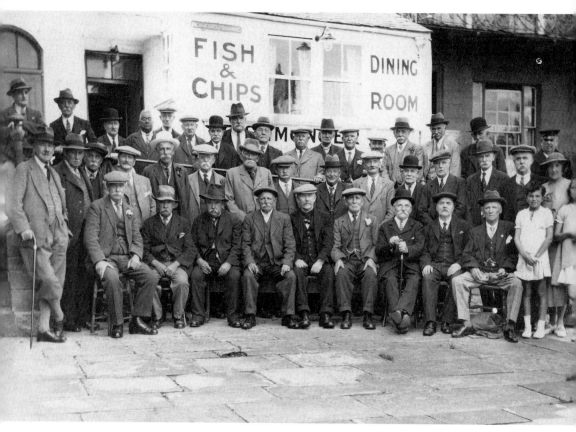

Chepstow Old Men's Club, *c.* 1930, with its founder, W. Clifford Thomas, standing left wearing plus-fours and trilby, apparently his accustomed costume at this time. Each year the men were treated to an annual Christmas Dinner at the fish and chips dining-room at No. 15 Beaufort Square, on the ground floor of the old White Hart, where they are assembled here. Some of the men's names are known. Back row, left to right: Mr Kicke, -?-, -?-, Jack Parris, -?-, Mr Bailey, -?-, Tom Foster, Bill Bastin, James Lee and, far right, Charlie Humphries. Middle row: W.C. Thomas, -?-, Mr Kirton, Charles Jones, Arthur Barber, George Davies, Charlie Jones, -?-, -?-, -?-, -?-, Frank Broome, Dennis Connell, -?-, Mrs Clifford Thomas and two girls. Sitting: -?-, Alvin Lee, Buster Lee, Jack Phillips, -?-, -?-, Mr Reardon, -?-, -?-.

Opposite above: Chepstow's first cinema was opened, adjoining the White Hart Inn, on 17 February 1912. The Electric Picture Hall was the creation of John Devereux Jones with his brother, Thomas Stanley Jones, who had worked together as electrical engineers. They converted the dilapidated coach house next to the White Hart which J.D. Jones had been running with his sister as a Temperance Hotel since 1894. Miss Jones also helped in the cinema, collecting the entrance money: sixpence for the seats at the back which were separated by a bar from the threepennies in front. The photograph was taken in September 1914.

Opposite below: The Electricity showrooms in the corner shop at the top of St Mary Street in the 1950s. They moved next door, to No. 7 Beaufort Square, after E.G. Walker's furniture and ironmongers closed in 1969. While electricity had been available in Chepstow since 1903, generated by the Chepstow Electric Lighting & Power Company in Orchard Place off Lower Nelson Street, it was not until after the Second World War and nationalization of the industry in 1948 that electricity began to reach the surrounding rural villages.

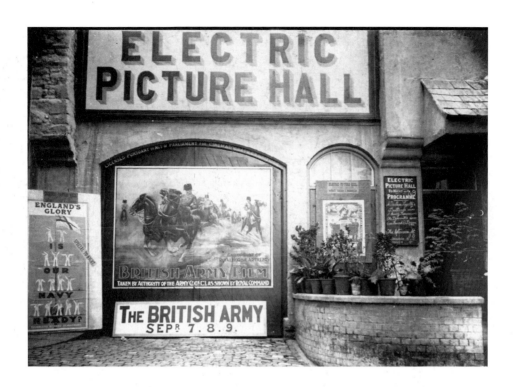

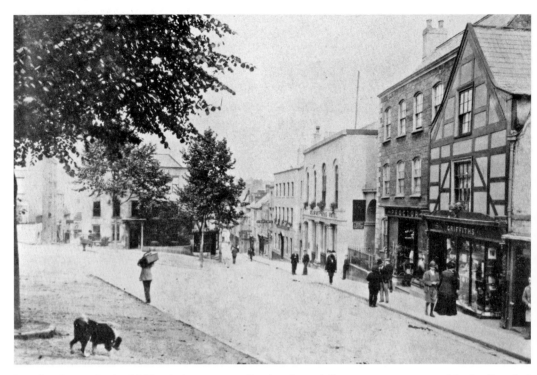

Beaufort Square in the 1900s. As it was centrally placed, road distances were measured to the Beaufort Arms Hotel. Adjoining the square, it was the Market House Inn from the seventeenth century, a main coaching inn in the early-nineteenth century, and a meeting place for organizations of all kinds; it was a hub of Chepstow life.

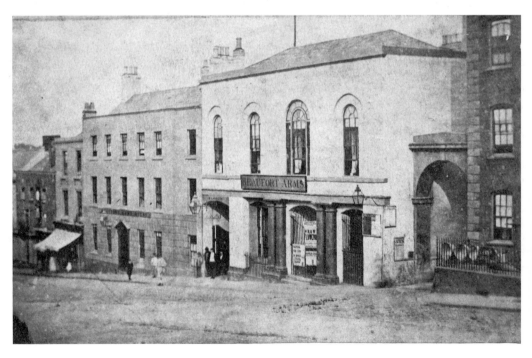

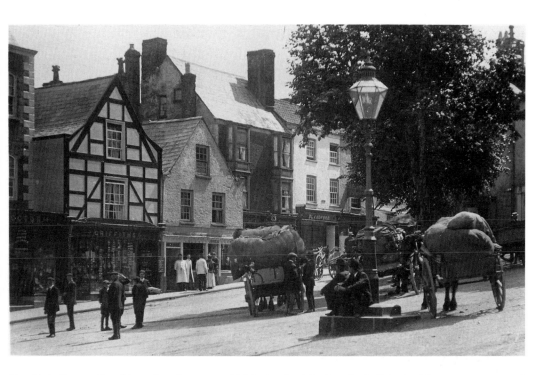

The High Street side of Beaufort Square, *c*. 1910. On the left, No. 4, Griffiths had been a printers and booksellers since the 1850s when Robert Taylor published local guidebooks and prints here. Thomas Griffiths bought the business in 1867 and it was continued by his widow Hannah and then by Ellen, herself a headmistress. Later the Tudor Café was re-developed by the Co-op in 1960. At No. 3 James Jones was butcher, (a Jones had had a butcher's shop here since the 1860s). No. 2 housed the studio of some early photographers (1875–82), one combining portraiture with hairdressing, but when this photograph was taken it was a shoe shop run by C. Broughton. The chemist at No. 1 at this time was Godfrey C. Wood who first called it the Beaufort Pharmacy. G.H. Blandford, the butcher, had been at No. 20 High Street since 1899, and their neighbour, just visible at No. 19, was W.H. Smith who remained here until 1968. The carts appear to be laden with sacks of wool. Chepstow's great annual fair held in June (on 22 June in Victorian times) was a Wool Fair. Selling the main commodity, wool, was the business part, the rest was pleasure and amusement. Beaufort Square and the streets around were filled with stalls, side-shows, cheap-jacks, and some pick-pockets.

Opposite below: The Market House with Assembly Rooms above, adjoining the Beaufort Arms Hotel, *c*. 1870. This building, demolished 1989, (and subsequently rebuilt using this photograph as evidence of the street level façade) was originally put up by the Duke of Beaufort in 1807 to provide a covered produce market. At the same time, a new range of butchers' stalls, 'shambles', was made behind, stretching back to Nelson Street. Note the grilled archway is still functioning as the entrance to the market house. In 1871 the landlord of the Beaufort Arms Hotel apparently brought the market to a close. The building was used by the hotel, the centre arches being filled with sash windows. The elegant Assembly Rooms above were the centre of Chepstow social life for much of the nineteenth century, with a winter season of balls and concerts. In the twentieth century the building became a new focus of entertainment when Enoch Williams began construction of the cinema, a project completed with Gaumont-British in 1938.

Margaret Lockwood graced the opening of the Gaumont cinema on 16 May 1938 when a full house saw the film *100 men and a Girl* starring Deanna Durbin. Gaumont-British presented a cheque to Chepstow & District Hospital whose staff were there. Left to right: Sister Williams, Matron Norman, Mr Saunders (cinema circuit supervisor), Diana Kent (who presented the bouquet), -?- Margaret Lockwood, Grace Ballinger, Nurse Dennis, Nora West. Right: Mr Coombs (cinema manager).

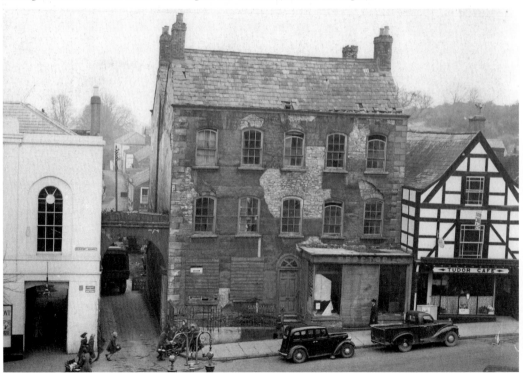

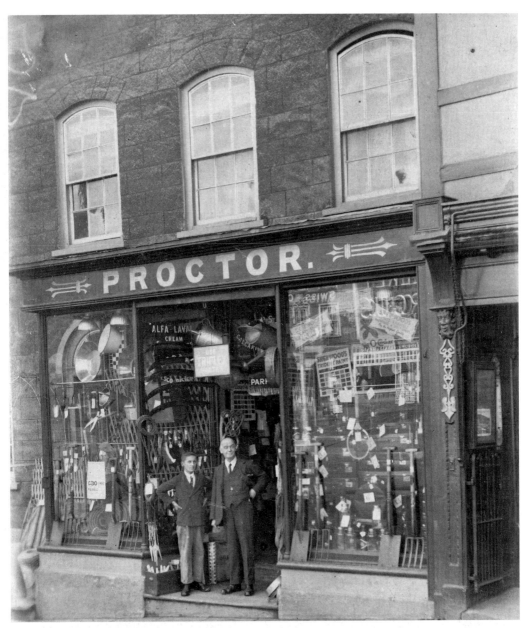

James Proctor's ironmongery shop had been at No. 5 Beaufort Square since 1858. After the Second World War when the building was used by the Home Guard and as a public air raid shelter, this large house became derelict and ruinous (bottom left). Some fine oak panelling was removed before its demolition in 1952 for the widening of Station Road. This also spelt destruction for the arch over the road, put up in 1836 and then considered to be an ornament to the town. Fragments of it could be seen on the side of the old cinema building until its demolition. Above, in the doorway, Robert Edgar (right) with ?.

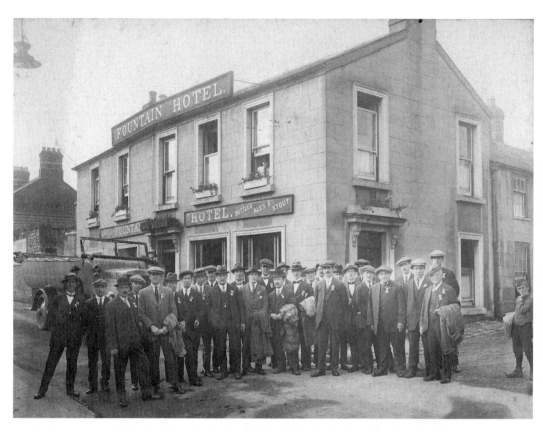

Gathering for a charabanc outing from the Fountain Hotel, around 1922. The Fountain stood on the corner of Upper Nelson Street and Station Road and was demolished in January 1972. It was called the Fountain after the source of Chepstow's main water supply for many centuries which welled up nearby. Since 1866 the Stroud Brewery had leased the inn and the adjacent yard, seen to the left of the building, which they used as a store.

Opposite above: Staff outside the Boys' Council School, *c.* 1930. This school was built on the 'Hilly Piece' in 1896 as the Boys' Board School and replaced an earlier, 1816, building in Meads Parade (Station Road). The road between the two was then called School Hill. When all school boards passed into the control of the county councils in 1902, the school became known as the Boys' Council School. Before its closure it had become Portwall Junior School. It was demolished in the late 1980s for a large housing scheme that now occupies its site and grounds. The staff here are: Standing, left to right: Ivor Waters, Harold Morris, Mr Tibbs. Sitting, Edward Johnson, Jessie James, Ellis Jones (headmaster), Mr Evans, Tom Laing.

Opposite below: The staff and their delivery vehicles outside the post office in Station Road decorated for the coronation of George VI in 1937. The postmaster, Mr Matt Phillips, is standing in the centre of the group. Despite local opposition to the removal of the post office from its town centre site in Beaufort Square, the premises in Station Road, were built and opened in 1923.

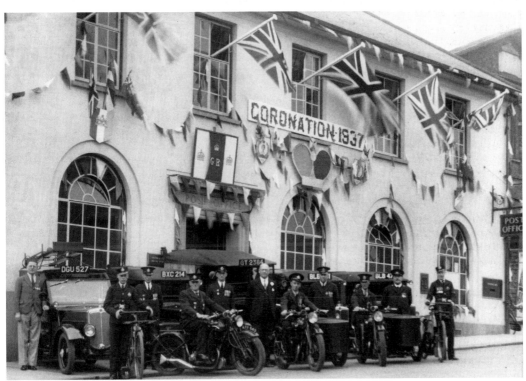

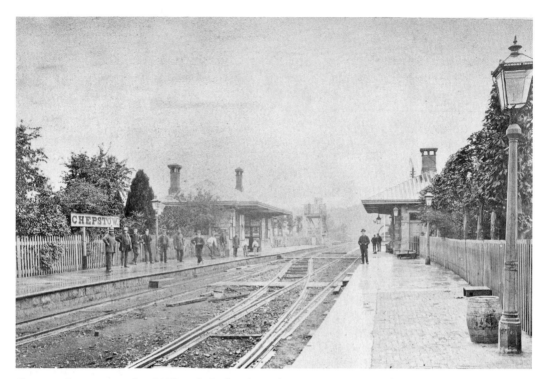

Chepstow Station opened in 1850 with the line from Chepstow to Swansea. The opening of the Wye Valley line to Monmouth in 1876 made Chepstow a busy junction and complaints were loudly voiced about the difficulties of embarking when the platform was nearly 3 ft lower than the carriages. An ambitious and novel scheme to raise the stone station buildings complete was accomplished by Chepstow contractor Cuthbert W. Whalley in 1877/8. As seen below, massive needles of timber were threaded through holes made beneath the string course. The building was braced together and jacks put beneath each end of the timbers. All the jacks were then turned in unison, turn by turn, and the building was gradually raised 22 inches. The platform was then built up underneath.

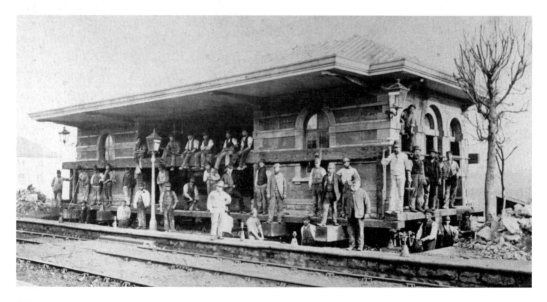

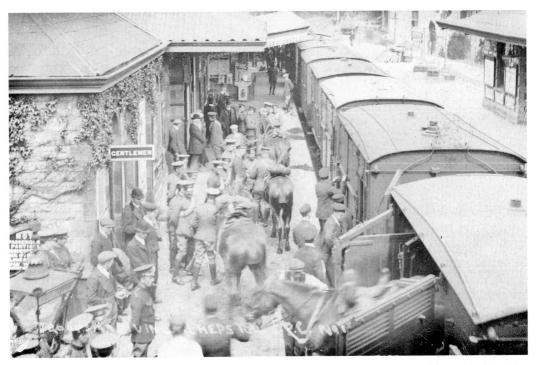

Disembarking men and horses of the Royal Gloucestershire Hussars Imperial Yeomanry on 15 May 1907, on their way to their training camp at Piercefield Park.

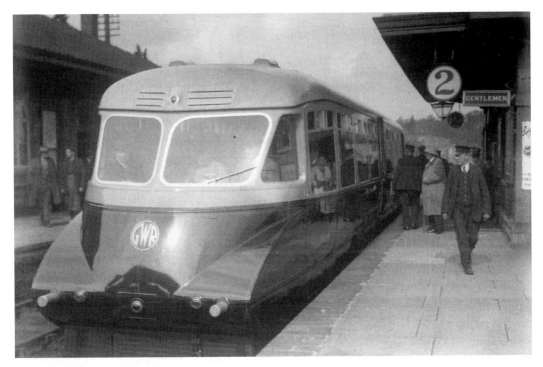

A streamline diesel railcar photographed at Chepstow station on 4 April 1936.

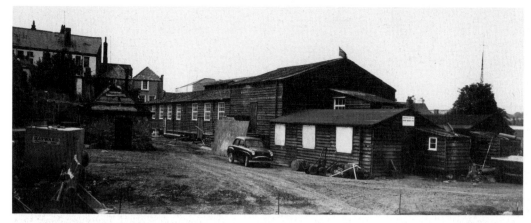

The Public Hall, in the grounds of the Gate House, was the home of concerts, exhibitions, auctions, political meetings, all kinds of activities put on by a variety of organizations for over 50 years. Towards the end of 1919 the Urban District Council arranged to purchase wooden hutments from the Disposals Board dealing with the National Shipyard at Beachley. For £300 they acquired 3 huts and a concert hall formerly used by German prisoners of war and, for about £2,000, these were reconstructed to provide a large hall entered through swing-doors from a crush hall. There was a fine stage with footlights and two dressing rooms behind. It was opened on 2 September 1920 by J.H. Silley, shipbuilder, who had given the ground on which it stood. After the ceremony 'The Futurists' entertained with songs, dances and an amusing sketch. The photograph was taken not long before demolition in 1973 in advance of the inner relief road (A48).

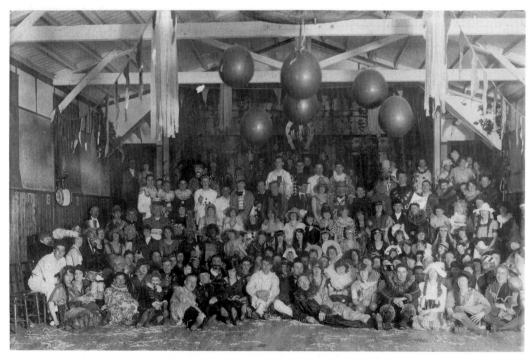

A fancy dress party inside the Public Hall, in the early 1920s. Does anyone know anything about it? The interior décor included, above the matchboarding, sheets of asbestos divided into white and brown treated panels ... forming 'a tasteful effect'.

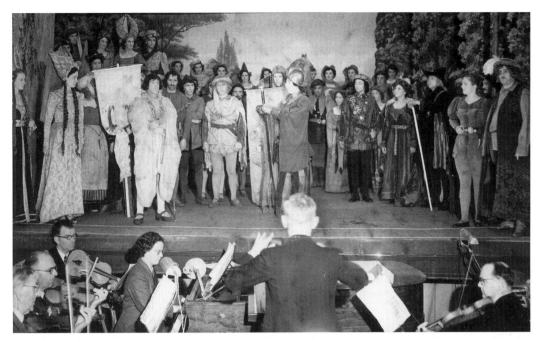

The Chepstow Operatic and Dramatic Society performed *The Vagabond King* in April 1953. The Society's shows are some of the best remembered events held at the Public Hall. It had been their venue since December 1920, and when the Society re-started after the war, in 1947, two plays and one musical were produced each year. Herbert Griffiths is conducting here. The producer and a talented leading performer for many years was H. Rimmer Clarke. The lead here was played by Harry Warren (third from left).

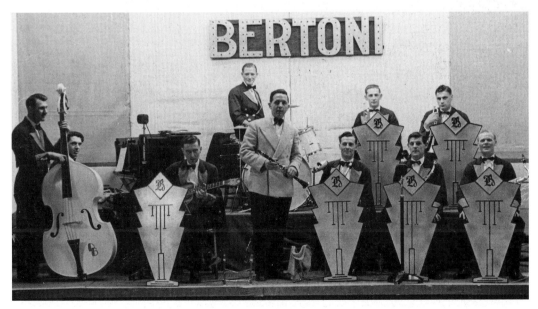

Bertoni's were regular performers at Public Hall dances, particularly those in aid of the Welcome Home Fund. Winners of local and regional dance band championships, the line-up here *c.* 1946 is, left to right: Dennis Bullen, Norman Griffiths, Ken Griffiths, Roy Meredith, Bob Phillips, Cliff Sadler, Des Pewtner, Stan Jones, Malcolm Griffiths and Ron Sjoberg.

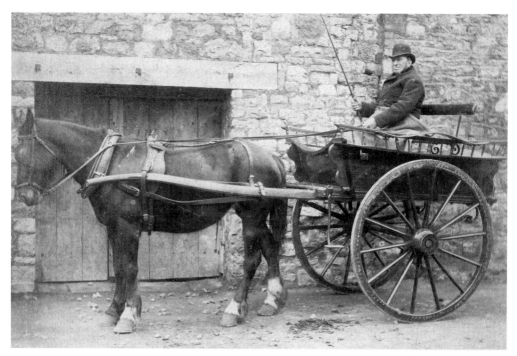

Mr Burridge with 'Old Leicester' outside the back of Proctor's Iron Stores in Upper Nelson Street. As well as the ironmongers shop fronting on the High Street (No. 17) Proctor's employed coachbuilders, wheelwrights, blacksmiths and farriers.

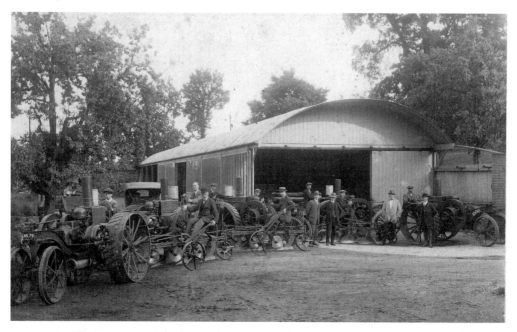

Proctor's had this agricultural shed across the road, on land between Upper Nelson Street and School Hill. With a display of implements are Alfred Proctor (third from right) and possibly his brother, Stuart Proctor (wearing boater), probably with employees, Robert 'Snuffy' Edgar (second from left).

Sparring partners meet in the back yard of the Bush Hotel, next door down to the Iron Stores. George H. Hutchings (fifth from left), landlord of the Bush from 1922–33, ran a boxing ring in the club room there. He was no stranger to the sport himself, having fought and won at the first 'Assault-at-Arms' in 1899 organized by the Chepstow Boxing Association, which was started by his father, George Hutchings. Left to right: Jimmy Owen, R.E. Watson, David 'Novice' Davies, Geo. Hobbs, Geo. H. Hutchings, -?-, Billy Hobbs, -?-.

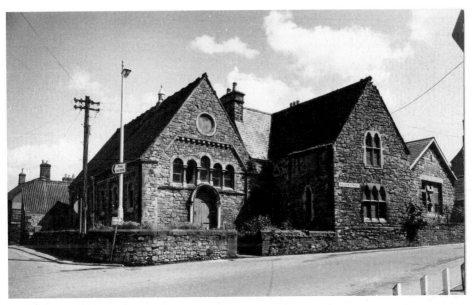

The Church School, which stood at the bottom of Lower Nelson Street on the corner of the Priory, near the church, was built in 1855. It was maintained by subscriptions and collections and had places for 150 children until it was enlarged in 1892. Girls and infants were taught at the school. The photograph was taken shortly before its demolition in 1973 when the Priory site was cleared and replaced by a car park.

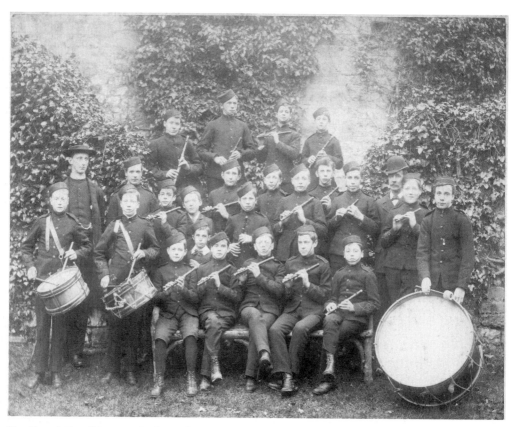

The Church Boys' Drum and Fife Band was begun in 1890 by the Revd Arthur Meggison (on the left) not long after he became curate at St Mary's. They made their first appearance at a church parade of Friendly Societies on 19 October 1890 when they 'played in a very creditable manner considering the short period the band has been in existence ...'. The following summer they took part in promenade concerts at Chepstow Castle with Elisha Williams as their bandmaster (possibly the bowler hatted gentleman in the picture). The Revd Meggison was popular and well-known for his hard work on behalf of the boys of the parish. Through his efforts and the generosity of a former resident, Mrs Bromedge, who saw his appeal for funds in the *Morning Post* and donated £250, the Church Boys House was built behind the church and opened in September 1893. A meeting place and club house for the boys, it consisted of a long room with removable partitions so that it could seat 500–600 people for public entertainments. The land adjacent was levelled with the help of the boys and a sports field prepared which ran up to the railway embankment. It was opened in June 1897, a few weeks before Revd Meggison left Chepstow for a new curacy. The ground and club house became the headquarters of the St Mary's Rugby Football Club, Cricket Club, Hockey Club and Association Football Club.

Opposite below: A more unusual ball game took place on the rugby football ground in the late 1920s: the Daily Mail Pushball Competition, played by the British Legion Women's Section. Those known are, standing, left to right: Aubrey Grassby, George Dade, Annie Seed, Paddy Murphy, -?-, Mrs Black, Mary Collins, -?-, Mrs Willis, Mr Swinney. Sitting: Audrey Hollins, Mrs Joe Jones, Mrs Watkins, Nina Robbins, -?-, Francis Priest, -?-, -?-, -?-. On the ball: Brenda Miller and ? Wilkins.

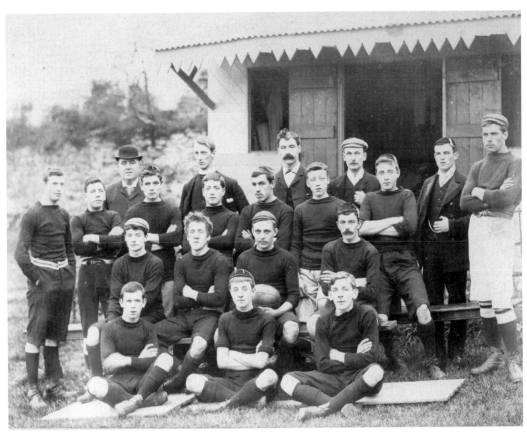

St Mary's Football Club with Revd Meggison, *c.* 1897.

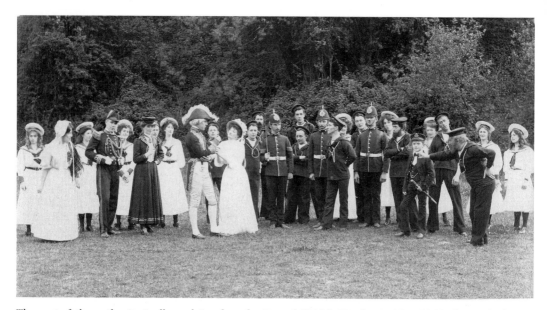

The cast of the enthusiastically-acclaimed production of *H.M.S. Pinafore* in May 1908, from which was born the Chepstow Operatic Society. The Church Boys House was the venue for this and their subsequent productions of Gilbert & Sullivan's comic operas until the beginning of the First World War. It was Walter Clifford Thomas, the Chepstow Castle pageant-producer, who stage-managed the first production of comic opera in Chepstow. 'Brilliant things have been done in Chepstow in the past but probably nothing so beautifully mounted and acted in the form of a stage play ever went to the credit of the town' declared the newspaper. Although most of the performers were 'ladies and gentlemen of the neighbourhood', a few principals were persuaded to come from further afield by Madame Flossie Sly, a teacher of singing who took the leading female role of Josephine. Two of her Chepstow pupils, Ethel Hurcum and Walter Thomas, also took principal parts and were feted for their performances. Originally scheduled to run for two evenings and a matinee, in the light of its astonishing popularity many had failed to gain admission and so a fourth performance was staged to another full house. The principal performers standing slightly to the fore in the photograph were, left to right: Ethel Hurcum, Walter Thomas, Ada Ballard, Randolph Gordon of Cheltenham, Flossie Sly, George Windows of Bristol (standing in profile), the next sailor L.P. Vaughan, Master Walter Martin, Bert Lewis and W.A. Weeks.

Opposite below: A grand mounted procession through the streets of Chepstow was a spectacular prelude to the 'Venetian Fête' on Wednesday, 2 August 1905, another in the series of fund-raising events for the restoration of the parish church. The fête itself was held in the castle, but the processionists, a colourful cast of characters on horseback and in decorated carriages, assembled on the Church Boys House Rugby Football ground at 5 p.m. where the 'snapshotting process' was concluded. This one shows, left to right: Robert W. Edgar as a 'British General', also the chief marshal of the procession, A.G. Pardoe as 'Old King Cole', Claude Edmonds as a monk, Willie Davies, the organizer of the event as a king 'beautifully costumed and mounted on a handsome horse used by Colonel Cody (Buffalo Bill) and ridden by the late President McKinley on the morning of his assassination (kindly lent by Capt. Corfield, Chepstow)' and W. Evans as a jester.

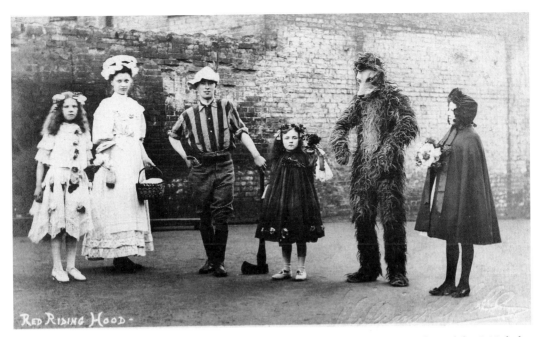

Red Riding Hood 'a grand cantata' was performed in the Church Boys House by members of the St Nicholas Guild under the direction of the curate Revd G.R. Jenkins on Wednesday, 24 April 1907. Originally scheduled for January, an epidemic of measles and whooping cough had caused its postponement. Red Riding Hood (far right) Flossie Bye, Wolf – B. Lewis, Woodman – P. Vaughan, Red Riding Hood's mother – Lorna Reed and Buttercup and Rose – Daisy & Flossie Vine.

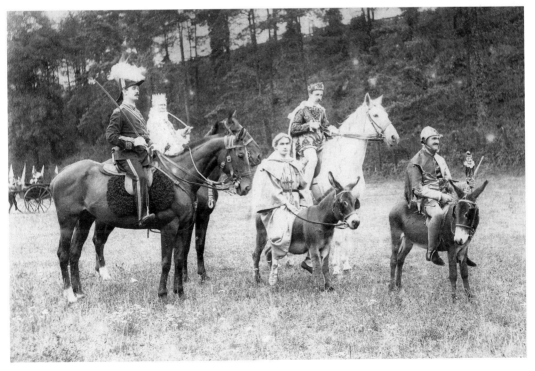

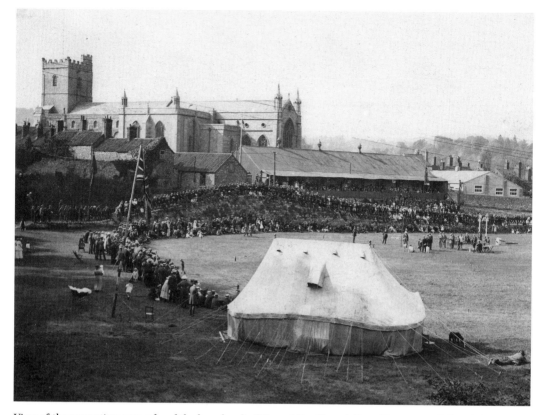

View of the recreation ground and the long low building of the Church Boys House crowded with spectators for the Standard Institute's annual athletic sports meeting. In May 1917 a Shipyard Workers Institute was opened to provide healthy recreation for the workers in Finch's and the Standard Shipbuilding Co. It was then intended that eventually a special building would be put up for the Institute but, in the meantime, with the shortage of appropriate accommodation in the town, the Church Boys House and ground was made available for immediate use. The Institute was run by a workers' committee. One of the first events organized was an amateur athletic meeting on 28 July 1917, which was to be held annually. It was deemed 'a triumph of organisation ... the delightful appearance of the enclosure and the clockwork precision in which the proceedings were conducted came in the nature of a pleasant surprise and added in no small degree to the pleasure and enjoyment of the very large crowd, a record one for the old Rugby field ...'.

Opposite above: One of the teams in the ladies' tug of war event. Note the linen trousers, overalls, jackets and caps worn by women workers in shipyards and factories in the First World War.

Opposite below: Sam Judd became the first holder of Major Green's Challenge Cup on 28 July 1917, presented by Mrs T.V. Ellis, wife of the managing director of Finch's. The 'versatile Sammy Judd' was the winner of the one mile scratch, open to men employed in the shipyards for which Major Green, one of the Standard Shipbuilding Company directors, offered a handsome challenge cup, value £25. 'The Welsh Junior Champion made practically all the running and going all out at the bell he finished with a sprint amid loud applause ...'.

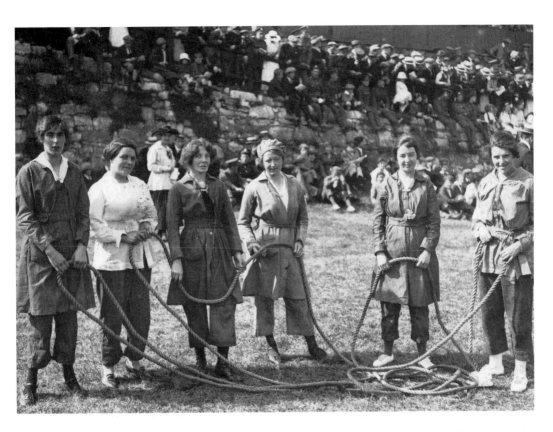

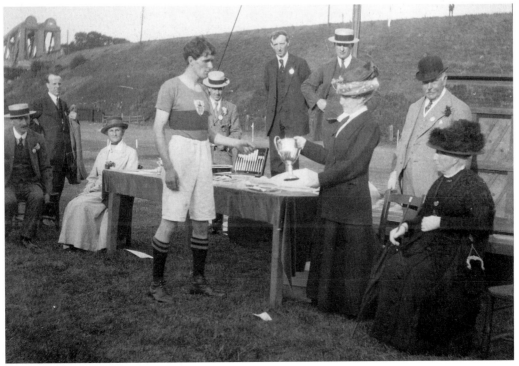

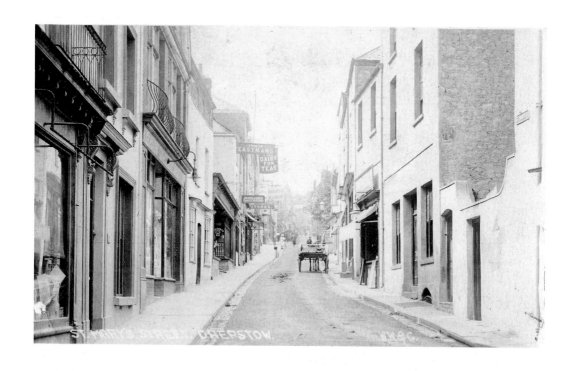

Above: Looking up St Mary's Street *c.* 1910. Left, note the double-fronted bow-windowed home of W.H. James, parish clerk and local historian. Next door is Thomas Sidney Davies' grocery stores at Nos 9 & 10, neighbouring butchers are Eastmans Ltd and James Jones at Nos 8 & 7, and 'The Dairy for Teas' banner hangs above the premises of C. Nicholas. The Golden 5 (now in Chepstow Museum) hangs outside H. Thomas & Sons grocery stores. Signs beyond are for Harris Restaurant and St Mary's Hotel both at No. 1.

Left: St Mary's Parish Church viewed from Upper Church Street. The Plough Inn's hanging sign has E. Williams as licensee. Elisha was landlord here in the early 1860s. The Plough closed in 1939. Note the cobbled road.

The Chepstow Co-operative Stores, No. 12 St Mary Street. This postcard carried on the reverse a printed invitation from the committee to members of the Chepstow Co-operative Society to attend the opening of the new premises on 10 January 1905 at 3 o'clock, to be followed by tea at the Church Boys House at 5.30 p.m. (tickets 6d.) and a public meeting at 7.30 p.m. The Chepstow Co-operative Society had made rapid progress not only with its new building – demolition of the old premises had started in August 1904 – but with its business. Begun in November 1896 by a meeting of 36 working men, the Society flourished under the management of C.J. Cole and by 1904 had a membership of 250. The new shop at 40 ft by 26 ft was said to be the largest in town. Designed by F.E.L. Harris, architect to the Co-operative Wholesale Society of Manchester, it had and still has an 'imposing and unique frontage'. At the back there was a large cooling shed and a bakery with a flour store above. The whole premises was lit by electricity and all the switches were controlled from the manager's office. Cllr H.J. Thomas, president of the Chepstow Co-operative Society, opened the building with a presentation gold key and the assembled company filed into the shop, where the manager's little daughter was the first purchaser.

Below: Manager, C.J. Cole, standing with hands on hips, looks well-pleased with the fine display of Christmas turkeys, 1907.

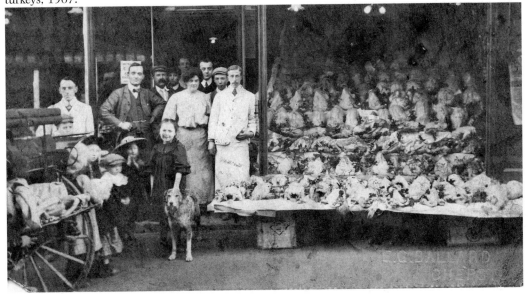

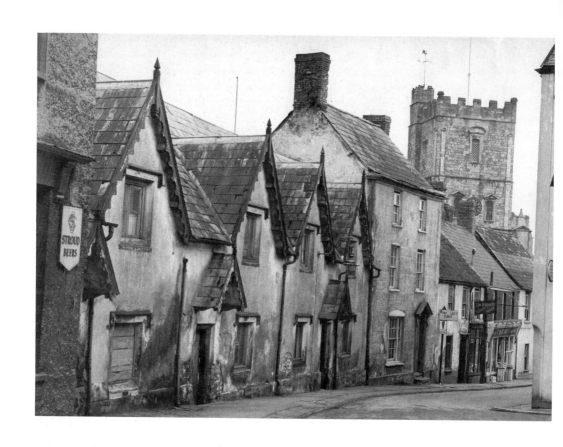

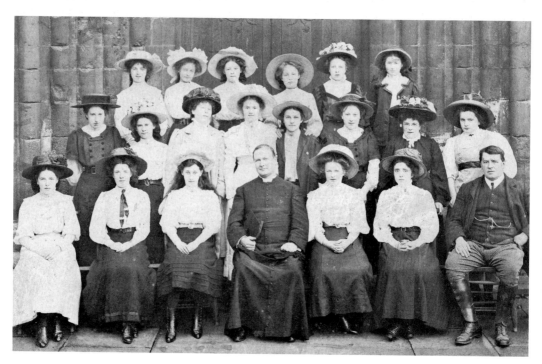

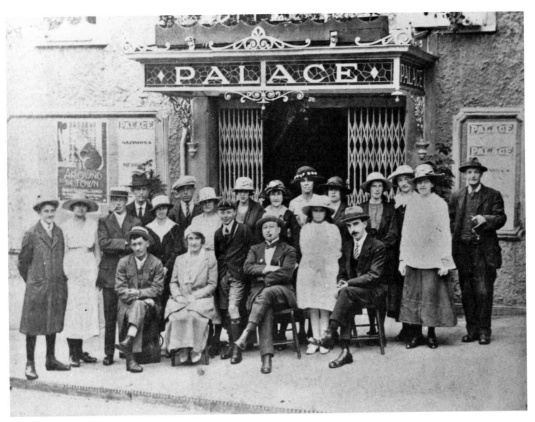

Staff and families gathered outside the Palace Theatre at the top of Bridge Street, *c.* 1920, now part of the Davis Court site. Put up during the First World War as a temporary cinema building to cater for Chepstow's much-enlarged population swelled by the shipyard workers, the Palace continued to entertain for 20 years. At its opening in July 1918 hundreds of people failed to gain admission to the initial performance which featured *The Whip* as the star film and included in its ambitious programme live comedy and variety turns and an 'excellent bijou orchestra'. Chepstow's Palace was one of a string of cinemas around the country built and run by Mr Albany Ward of Weymouth. Gaumont-British took it over in 1927 and, when their new cinema was opened in Beaufort Square in 1938, the Palace eventually closed. Left to right, standing: boy in projection booth, Mrs C. Goody, James Firth (projectionist), -?-, Mrs Firth, Reg Phillips, -?-, Baron Samson (manager's son), -?-, Miss Cavill (cashier), Mrs Phillips, daughter of pianist, -?-, Queenie White, Hetty Cavill, -?-, -?-. Seated: Dick (stage manager), Mrs V. Samson and Mr H. Samson (the cinema manager), the pianist.

Opposite above: Upper Church Street, showing the Montague Almshouses in a dilapidated condition in 1955 before they were rebuilt retaining the façade. Named after Sir Walter Montague, who bequeathed his house and garden in Chepstow to be converted into almshouses and made provision for the maintenance of the inmates in his will of 1614, it housed five men and five women.

Opposite below: In front of the Norman doorway in the west front of St Mary's Church the Revd Percy Treasure, vicar of Chepstow from 1905–1909, with a group of wonderfully hatted young ladies. Front l–r, Alice Judd?, Lily Judd, -?-, Rev Treasure, Gladys Bailey, Mary Judd.

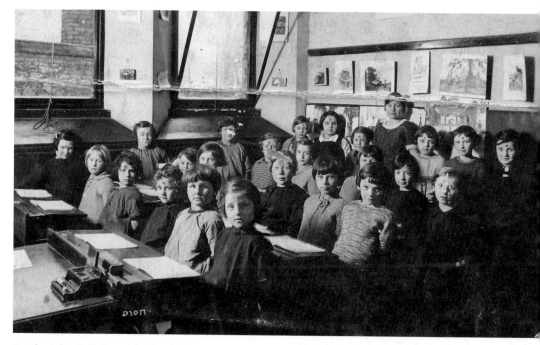

Pupils at the Girl's Council School (the Board School), in the classroom – a change from the more usual line-up outside school. The Board School was built and opened in 1878 to provide proper accommodation for girls and infants. They had been taught in the schoolroom belonging to the Congregational Chapel in Welsh Street since 1873 after the School Board was started, while the boys were then taught at the old National School in Station Road. The Bridge Street school closed in 1964 and the building became Chepstow Museum's home until 1982. Girls so far known (more identifications please) are, left to right, front row: -?-, -?-, Dillys Davies, Anne Watkins, -?-, Marjory Ballinger. Second row: Gwen Dyson, -?-, -?-, Rose White, -?-, Joan Bull. Third row: second from right, Kitty Scott. Back row: far right, Kathleen Hurd, second left ? Townsend. Teacher – Miss Watkins.

Opposite above: Gwy House, in use as the Red Cross Hospital during the First World War. Photographed, 1916, from Gwy Meadow (now the Castle car park) which W.R. Lysaght lent as a recreation ground for the soldiers. Until the early twentieth century the house remained a private residence, but inspite of its subsequent institutional uses as school and hospitals, Gwy House still retains many of its original eighteenth-century features and layout.

Opposite below: Hockey playing girls at the Gwy House School for Girls, in the gardens at the side of the building. None of them has been identified and as the school took boarders they may not come from local families. 'Church High School for Girls' was opened at Gwy House in 1907 by the Misses du Bochet. Gertrude, the elder sister, was principal, Alice taught music. The school therefore offered a 'good modern education with special advantages in music'. Tennis and cricket were also played 'under proper supervision' and special arrangements were made to suit individual girls, 'care being taken to avoid undue pressure'. Lessons were also given in woodcarving, metal working and book binding. In 1913 the du Bochets left Chepstow to take over the St Mary's Hill School at Horsell, near Woking.

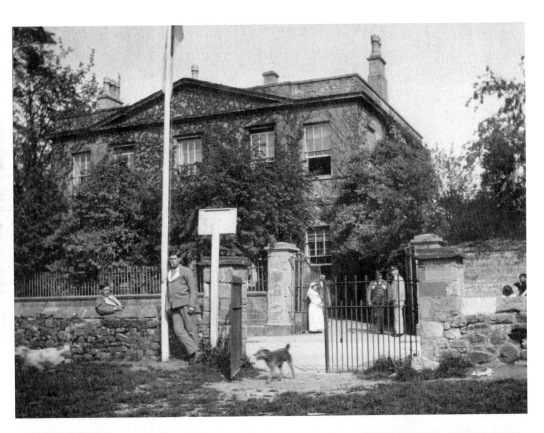

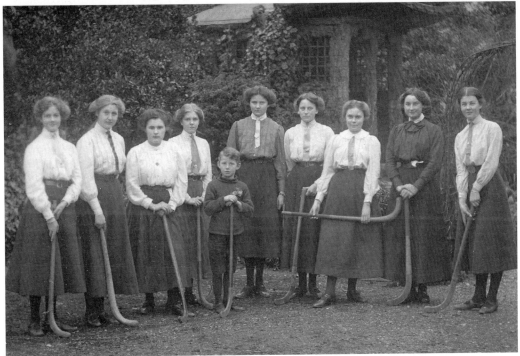

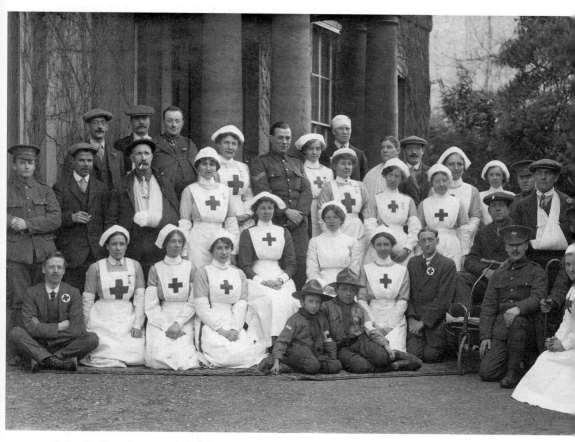

Above: Staff and patients, the first draft of wounded soldiers who arrived on 17 March 1915, in the forecourt of Gwy House Red Cross Hospital. The owner of Gwy House, T.V. Ellis (manager of E. Finch & Co.) offered it for hospital use in November 1914. It was equipped largely by gifts of furniture, linen and utensils collected by ladies of the neighbourhood and maintained by numerous daily gifts of food etc. It was run entirely by the Chepstow Red Cross Detachment. The VAD nurses worked unpaid, under a lady superintendent – a trained nurse, Emma Goold – and the hospital was run by a commandant, Mrs Stacey of St Pierre until October 1916, then by Miss Corben and later Mrs K.L. Francis. While the names of the nurses are known, only some can be put to the faces. Front row, left to right: Miss E. Griffiths and Miss G. Tilley, (far right) Miss May James, (centre seated left) Mrs Stacey, (right) Miss Emma Goold. Standing to left of Mrs Stacey is Miss Alison Lysaght. Back row, second nurse from left is Miss Violet Curtis, second from right, Miss Alberta Jolliffe. The two boy scouts are (left) Jack Blandford, (right) Herbert Griffith. The convalescent men were well entertained with sports, concerts, car rides, boat trips and tea at the homes of local gentry. They also made their own amusements.

Opposite above: The Gwy House Band making minstrel music. The men staged several concerts for the townspeople.

Opposite below: The presentation of an ambulance to Chepstow & District Hospital, 20 July 1940. In the background is the nurses' home demolished for Gwy Court housing. After the First World War the need for a hospital for Chepstow became urgent with the increased population. Gwy House was bought, equipped and opened in September 1921, with half of the cost raised by public appeal. Chepstow & District Hospital closed in 1976 and Gwy House is now the home of Chepstow Museum.

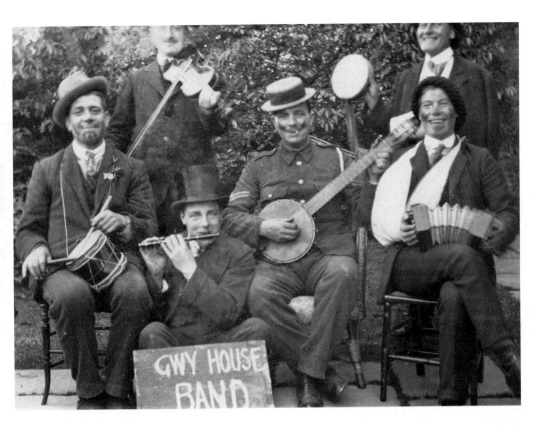

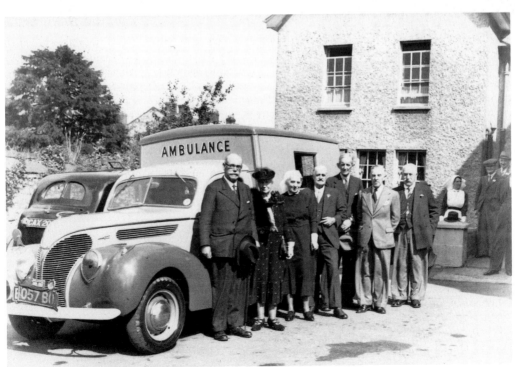

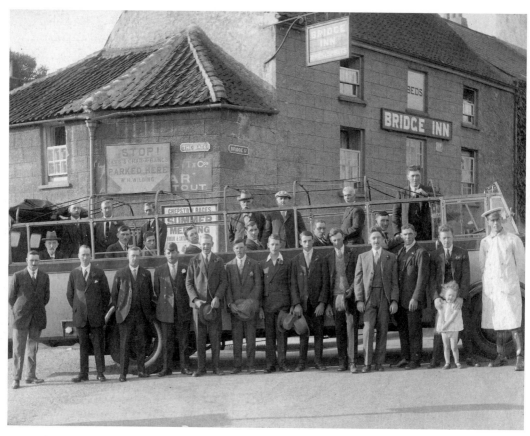

Outing from the Bridge Inn in 1928. Mr W.H. Wilding was the landlord here from 1926 and, after his death in 1949, Mrs Wilding continued to run it until 1968. It was renamed the Bridge Inn while the cast-iron bridge was under construction in 1815. Previously it had been called the Ship, reflecting the nature of much of its earlier trade.

Opposite below: Further up a leafier Bridge Street, *c.* 1909. On the left No. 18, then known as Tintern House, had only one resident. The row of three newly erected 'convenient villas' known as The Gables were occupied by the Misses du Bochet, who ran the school at Gwy House, Miss A. Cooper and Mr W.A. Weeks. Immediately on the right, No. 30 'Vine Cottage' was a large house with a laundry run by John C. May. The boys are probably carrying washing in their baskets.

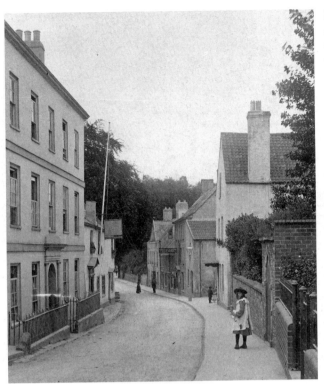

Down Bridge Street, *c.* 1908, when Arthur Edgar Richards was landlord at the Three Tuns, an inn since the early-eighteenth century. That year too, 'Cromwell House', the garden through the arch and Ashburne House were all put up for auction. Cromwell House is so called after the claim that Oliver Cromwell slept there after he had taken Chepstow on 11 May 1648. Ashburne House had been a school for young ladies since *c.* 1890 run by the Misses Kingston and Mrs Maples. They left Chepstow in July 1907 and the school was taken over by the Misses du Bochet who soon after moved it across the road to Gwy House. The sign outside Nos 12 and 13 on the right, reads 'wholesale and retail sweet supply', a business run by Mr and Mrs James Kennedy for many years. They sold fruit as well, had a restaurant and let rooms. The last building visible on the right is No. 16 'Woodfield House', then occupied by Sidney J. Richards, a builder.

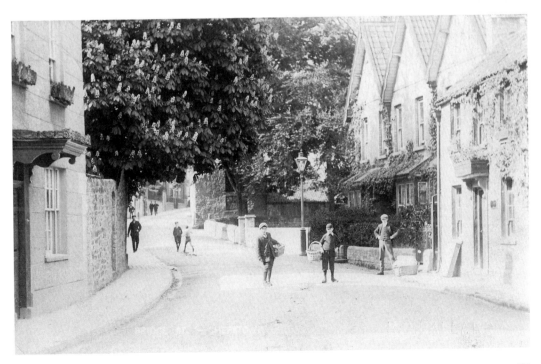

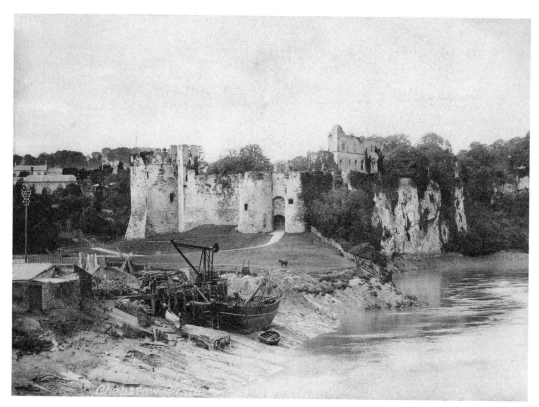

A popular view of Chepstow Castle from the bridge. Photographs could not help but include some of Gwy Wharf and often the trow *Alice*, seen here with mast lowered. The *Alice* was built on the other side of the road bridge in 1868 by George Fryer in his yard at Gunstock Wharf (now riverside gardens). She was used mostly for importing coal which was the mainstay of the business at Gwy Wharf from the early-nineteenth century. When E.H. Weeks bought the wharf in 1894 from Thomas Sargent, a coal and salt business came with stock, horses, wagons, coal weighing machines, weighbridge etc, and the *Alice* with her gear, a boat with oars, landing stage and crane which can be seen here. As well as the 220 ft river frontage, known also as the Bridge Coal Wharf, there was a large yard adjoining used for selling and making bricks and tiles (it is possible to see the smoking chimneys of the kilns in the picture on page 26). It was also used as a timber yard with planing and saw mills. The site has continued to be a builders' merchants.

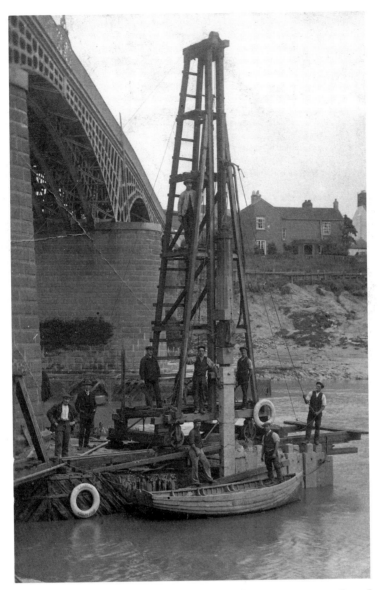

Repairing the road bridge in 1914. The foundations were strengthened by driving concrete piles into the river bed. In charge of operations was engineer, Mr Goodman (second from left). The ironwork of the central span had been strengthened in 1889, with additional ribs that were put underneath by E. Finch & Co. Nonetheless, the cast-iron bridge, completed in 1816 by Hazledine, Rastrick & Co., carried the main road link between England and South Wales for 150 years, withstanding loads and vehicles that its designer John Urpeth Rastrick could not have begun to contemplate.

Mr & Mrs William Royse Lysaght photographed in the garden of Castleford a few days before their golden wedding on 3 July 1940. Since his retirement that January as Chairman of John Lysaght Ltd, the firm founded by his uncle, the Lysaghts lived mostly at their country residence in Devon. W.R. Lysaght

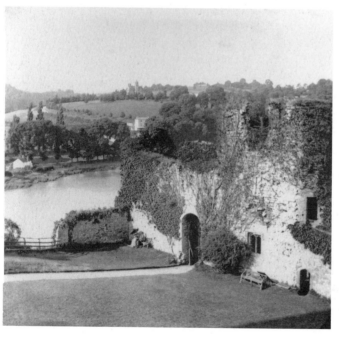

came to this area in 1901 to take control of the company's Orb works at Newport, new sheet steel mills begun in the 1890s, moving from Wolverhampton where he had met and married Elizabeth, daughter of Revd J.E. Gladstone, a first cousin of the Grand Old Man. They moved to Castleford, a Victorian Gothic mansion, in around 1907. The house commands a splendid view of Chepstow Castle which Mr Lysaght purchased in 1914.

Left: Both properties at an earlier date, Castleford at that time having a tall tower. Its extensive gardens were renowned.

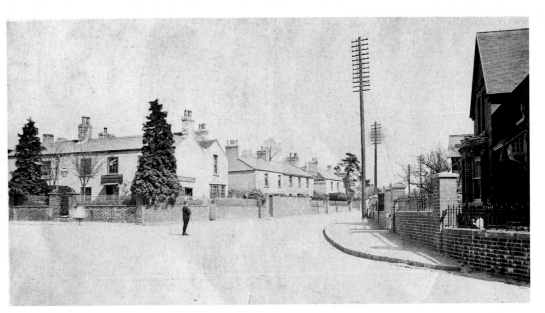

The crossroads at Tutshill, *c.* 1906, when it was safe to stand in the road. The Cross Keys occupying the corner as it had done at least since 1843, has now closed its doors for the last time. Down the Gloucester road, beyond the early-nineteenth century houses, the grocer's shop, then run by Arthur King, is no longer in commercial use.

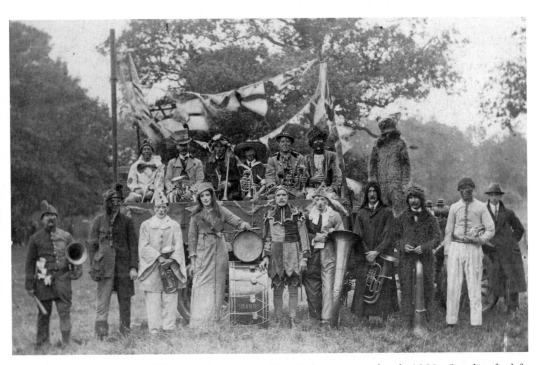

The Tidenham Band with a difference! The occasion identified as a carnival early 1920s. Standing far left, George Jones, bandmaster, his sons Bert (bass E flat), Bill (cornet on cart) and Arch Jones (dressed as bear), brothers John and Cyril Hollins, Frank Steele and John Lewis, tenor horn, also identified.

The formal gardens of clipped yew hedges and topiary at Sedbury Park. The photograph was taken when the house had become a luxury hotel in the 1920s. At the sale of the estate in October 1920 the beautifully laid out gardens were a special feature of Sedbury Park.

Left: Eleanor Ormerod, youngest of George Ormerod's 10 children, was born at Sedbury Park. She achieved wide recognition as an entomologist, studying the insect pests of plants, becoming the first woman to receive an honorary doctorate from Edinburgh University.

Right: Georgiana E. Ormerod, six years older than Eleanor, they were constant companions and she assisted Eleanor by producing drawings of insects. She died in 1896, Eleanor five years later. The photographs were taken in 1886.

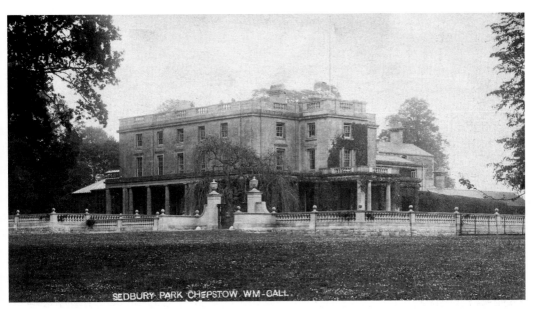

Sedbury Park was given its name and much of its character by George Ormerod, antiquarian and wealthy Lancashire landowner, who bought 'Barnesville' in 1825. He employed the architect Robert Smirke to make alterations, including the colonnade with portico and a single storey building connected to the main house for his great library. Further additions were made to the house in around 1898 by Sir William Henry Marling, adding two storeys above the portico, the balustrades on the house and the forecourt enclosure.

Local men were given a 'Welcome Home' by the Marlings at Sedbury Park in 1919.

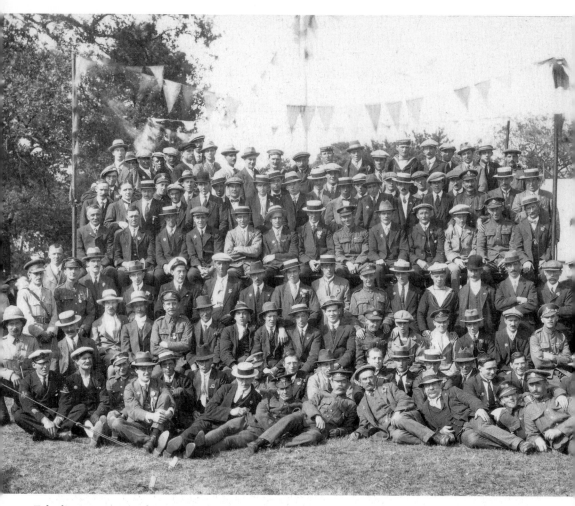

Tidenham gave its 'Welcome Home' reception to local men who had returned from the First World War on August 1919. A present was made of the photograph to the men in it by the Welcome Home Committee.

Almost a panoramic view of boys and bicycles outside the front gate of the Mead School, Sedbury in 1894. Walter A. Warne (fourth from right) opened his 'most comfortable home school for boys' in 1892 and, five years later, disposed of it to Albert Loveys. Being a boarding school, not all the boys in this photograph are local. Those known are, left to right: Gilbert Humphreys (Newport), Dunlop Hadley, Perry Dovey (Neath), Austin Thomas (Carmarthen), W. Price (Coach & Horses, Chepstow), C. Gordon Jolliffe (Chepstow), Senn (?) Hadley, W. Bailey (School House, Itton), -?-, W.A. Warne (headmaster), Will Graham, Mr Hager(?) (language master), Mr Mackie (master).

Members of the Chepstow bicycle club outside the Beachley Coffee Rooms, c. 1890, where they occasionally had dinner after a race. The Coffee Rooms, later called The Pier Hotel, was built at around the same time as the ferry pier which it faced, in 1825, when improvements were made by the newly-formed Old Passage Ferry Association. It closed for business when Beachley was taken over by the Admiralty in September 1917 for the building of the Shipyard

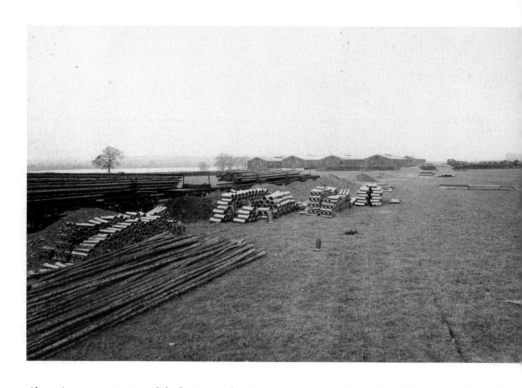

Above: A panoramic view of the hutments for German prisoners of war at Beachley Camp, November 1917. The creation of National Shipyard No. 2 dealt a tragic blow to Beachley for, in September 1917 under the Defence of the Realm Act, Beachley was acquired and partitioned off after all the villagers had been evicted from their homes with just 11 days' notice. Work began quickly with the making of a railway line to link the site with the main line a mile from Chepstow. The first hutment accommodation was used for the German prisoners of war so that their close supervision could be maintained. This was occupied by the end of December but huts for the soldiers, who were billeted in buildings in Chepstow and Beachley, were unfinished. This caused questions to be asked of the First Lord of the Admiralty regarding the relative living standards of the prisoners of war and British soldiers. By this time there were 2,000 German prisoners at Beachley. National Shipyard No. 2 was planned to have 18 slipways which it was reckoned would give employment to 6–8,000 men. A power station was built (its cooling tank was to become Beachley swimming pool) and (right) a 1,000 ft long fitting shed was constructed. The shipyard generated more building with the camp at Sedbury and houses for shipyard workers at 'Pennsylvania' on the garden city model. No ship was ever built at the Beachley yard, which had cost over £2 million. This bold, some say foolish, project was abandoned in 1919 and a Disposals Board set up to sell off the redundant equipment and buildings. There were still numerous huts on the site when the Army was looking for a location for their new school for apprentice tradesmen. The Boys' Technical School, latterly known as the Army Apprentices' College, was opened at Beachley in 1924. 'Pennsylvania' was also bought for married staff quarters. The College closed after seventy years, in 1994, but the site has continued in Army use. Beachley Barracks is now the home of First Battalion The Rifles (1 Rifles).

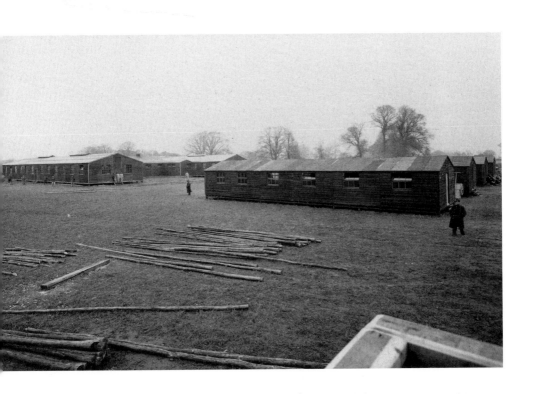

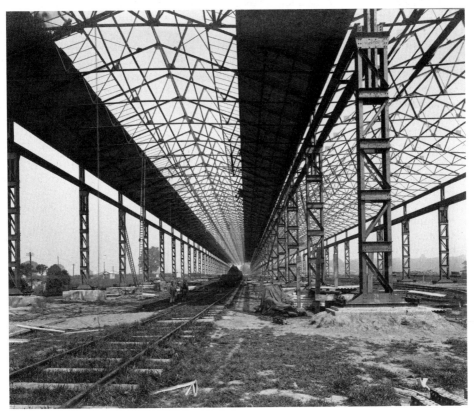

The twentieth-century revival of the Old Passage Ferry from Beachley-Aust was the creation of architect Enoch Williams. His first purpose-built car ferry, the *Princess Ida*, launched in 1931, was followed soon after by the *Severn King* and, in 1959, the *Severn Princess*, providing a continuous 20 minute service. Below, the special turntable feature literally dreamed up by Mrs Ida Williams which made loading easier and increased the number of cars carried.

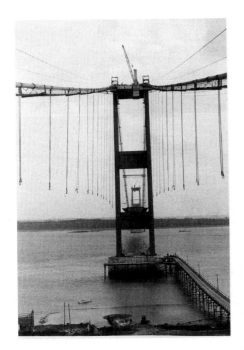

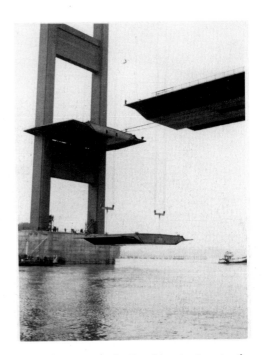

Almost 150 years after Telford proposed a suspension bridge to span the Beachley-Aust route, the Severn Bridge was opened in 1966, then the longest span suspension bridge in Britain at 3,240 ft. Chepstow's Fairfield Shipbuilding & Engineering Co. assembled the deck sections which were launched from the yard, towed to the site and winched into position – top right. *Above left*: the deckhangers, hung from the main cables, await deck sections. *Below*: construction of the Beachley viaduct. Fairfield also fabricated the deck sections of this and the Wye Bridge. The deck is carried over the peninsula on splayed steel-hinged trestles.

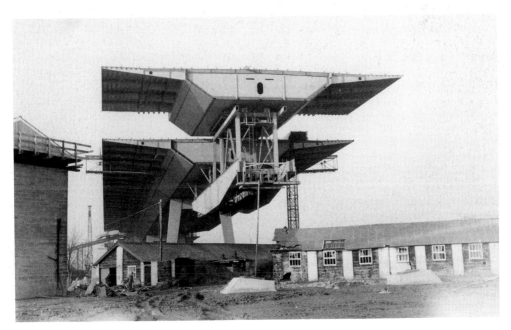

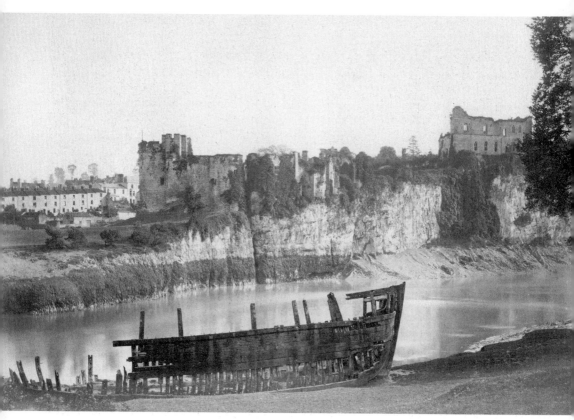

A romantic picture of two ruins! The rifts and hollows beneath Chepstow Castle and the river bed beyond became the subject of close scrutiny in an unusual quest, in the early twentieth century. An American, Dr Orville Owen (top far right), pursuing the theory that Francis Bacon was the real author of Shakespeare's plays and that he concealed his manuscripts but left clues as to their whereabouts, worked out a complicated system for decoding ciphers that he could find hidden in the works of several Elizabethan authors. Dr Owen came to the conclusion that the manuscripts were concealed in iron boxes somewhere near Chepstow Castle. Directed by ciphers he found in Sir Philip Sidney's *Arcadia*, his first fruitless search was in Peglar's Cave, near the castle in 1909. After further study, this time of *The Tempest* he turned his attention to the River Wye itself, and in the early part of 1911 excavated a number of holes in the bed of the river, about half a mile above the castle. He was looking for a rift in the river bed in which, according to his cipher, Bacon had bricked out a vault to contain over 60 lead lined boxes. In these were lead wrapped books and manuscripts that would also prove Bacon's real parentage – Queen Elizabeth and the Earl of Leicester – so Owen believed, and his search attracted massive media interest. Although he failed to find the boxes, he did uncover one of the timber platforms of the Roman bridge. Two further investigations were made before Dr Owen returned empty handed to America. One was in a cistern discovered beneath the rift below the castle's cellar, the other on the Gloucestershire side of the bridge. There were later attempts to locate the elusive manuscripts. Another American, Dr Prescott, was reluctantly allowed to dig beneath the castle cellar until his work appeared to be endangering the structure. Fred Hammond also carried out excavations inside the first court of the castle in 1924. He was looking for access into a walled up chamber by Marten's tower, which he had pinpointed as a possible location using Dr Owen's original cipher instructions. The boxes remained undiscovered and controversy still goes on about who could have written Shakespeare's plays.

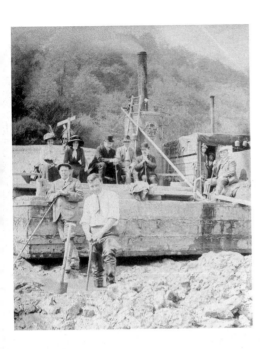

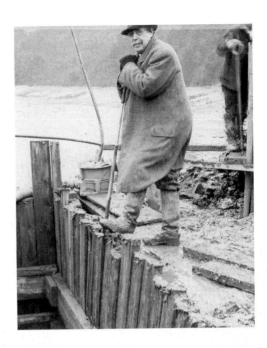

Dr Orville Owen (top right) and his excavations in the bed of the River Wye which were supervised by Fred Hammond, Chepstow engineer. Up to 24 men were employed digging out the mud. The excavated shafts had to be closely timbered to stop the mud sliding back in (above right and below). Work was only possible in the few hours, day and night, when the tide was out. Every time it came in the excavation shafts filled with water and had to be pumped out by a large 'pulsometer' supplied with steam from a boiler mounted on a floating pontoon (above left).

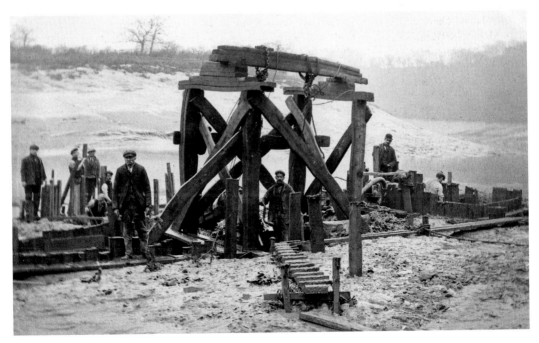

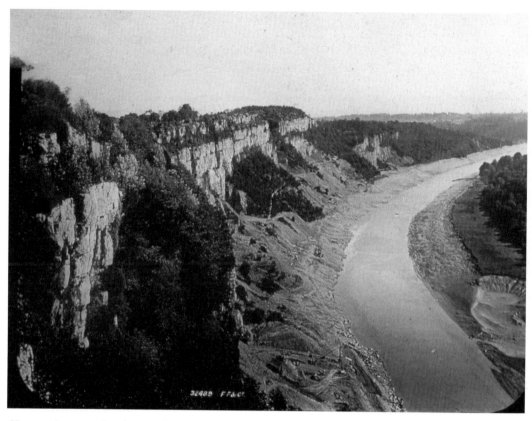

Views at Lancaut also showing limestone quarrying from the riverside cliffs and a trow, one of the vessels used for carrying the stone.

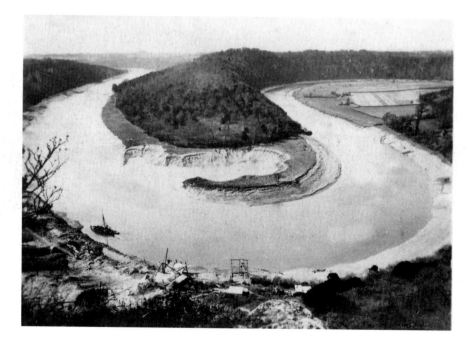

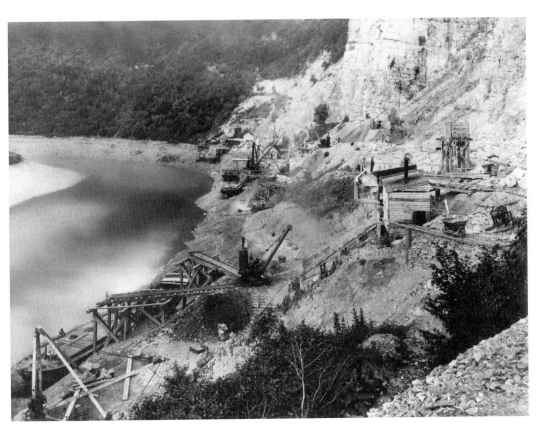

Workings at Lancaut quarry.

The ruins of St James Church at Lancaut, in the 1920s. Of Celtic origin, it seems its first dedication to the Welsh St Cewydd or Ceuid gave Lancaut its name. It possibly served a small settlement of river traders and fishermen which, when Offa's Dyke was created, was left in Welsh hands. The ruined church, the product of building and alterations at different periods, has now been preserved.

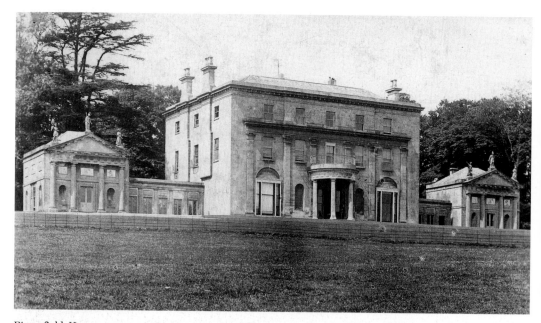

Piercefield House, now a ruin, once a magnificent mansion amid beautiful scenery. Its fame in the eighteenth century was for its Park and Walks which were the creation of Valentine Morris. He laid out a path through the woods along the cliff, from which breath-taking vistas could be enjoyed from seats placed at carefully created vantage-points. These were all given names, some romantic and fanciful. The Walks came to a peak on the Wyndcliff which was then within the grounds of the house. Valentine Morris welcomed visitors and the Piercefield Walks were a major attraction of the Wye Tour. The house as it is seen here was developed by later owners. George Smith, who bought the estate from the impoverished Morris in 1784, commissioned John Soane to draw up schemes for the house. Work was still underway when Smith was bankrupted in 1793 by the failure of the Monmouthshire Bank which he had co-founded and the unfinished house was sold. The purchaser, Sir Mark Wood, altered and embellished the house. He added the two wings and the portico. This led into the saloon or entrance with mosaic pavement, pilasters, a porch with painted glass fanlight and doors with mirror panels which reflected the panoramic view from the house. There was a grand winding staircase and other rooms were lavishly finished and furnished. The Clay family lived here from 1861 until the 1920s. Henry Hastings Clay sold Piercefield to Chepstow Racecourse Company, of which he was a director, and the famous Chepstow Racecourse was created in the park and opened in 1926.

Opposite above: The Hon. Mrs Bathurst at the Chepstow Agricultural Society's Show at Piercefield Park in 1909. It was the venue for the show since the first in 1899, after Henry Clay, founding president of the Society, offered to host the event in Piercefield Park.

Opposite below: The Curre Hunt Meet at Piercefield in 1908. Note the white foxhounds for which Edward Curre's pack was well-known at this time.

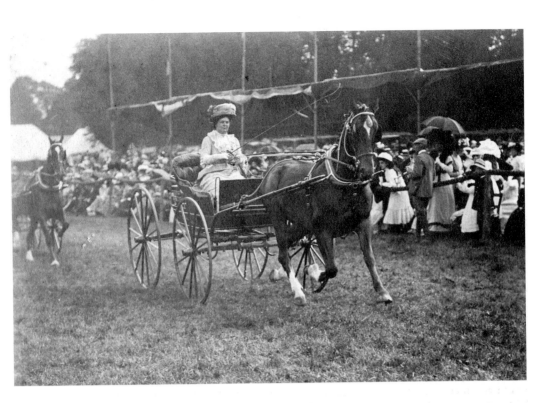

143

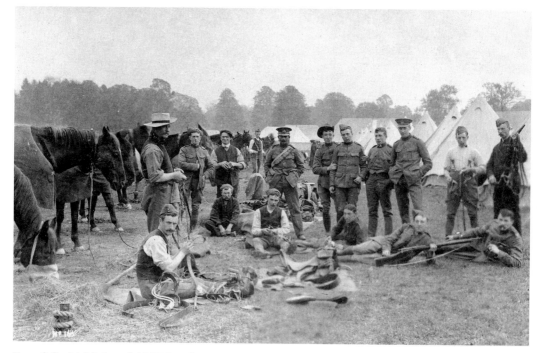

One of the highlights of 1907 for Chepstow was the visit of the Royal Gloucestershire Hussars Imperial Yeomanry to Piercefield Park where, by courtesy of Henry Clay, their training camp for that year was held from 15 May–1 June. Officers and men were apparently 'charmed with the beautiful situation of the park and were equally surprised and impressed with the cordial way in which they were welcomed by the townspeople'. The town was 'a blaze of colour and the Beaufort Square is looking gay and smart with streamers suspended from many points'. Shopkeepers of course had good reason to put the flags out, as the Imperial Yeomanry's visit was a welcome fillip to trade. Training was not confined to Piercefield Park; the grounds at St Pierre, Oakgrove and Itton Court were all made available. One of the principal events of the training was an exercise in a 'convoy scheme' when ten baggage and ammunition wagons had to proceed under escort, as quickly as possible, from Usk to Chepstow across country, while a hostile force tried to locate, harass and capture it. In the concluding days of the camp, thousands of people witnessed the regimental sports.

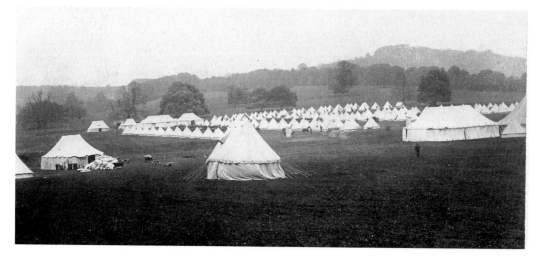

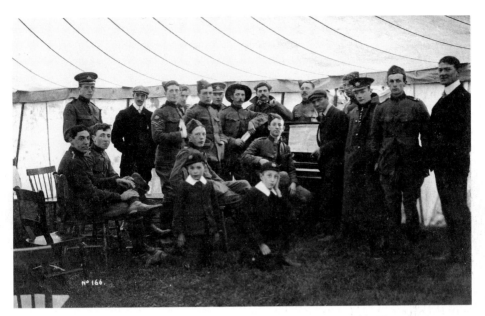

Entertainment was a feature of the camp. The final smoking concert held in the mess tent included the 'well-known Gloucester comedian Tom Hay' as well as contributions to the programme by some talented troopers. At the Monmouthshire Squadron's own smoking concert, soldiers and townspeople saw comic turns and 'mutual telepathy and neutral magic' (thought reading).

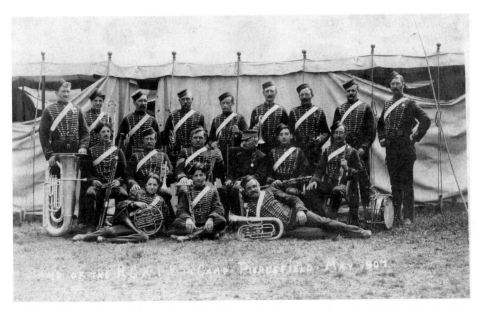

'The Bandsmen are wearing the bright uniform of the Hussars and the band will perform at intervals and also during the progress of various functions associated with the camp.' One of the most spectacular being when they led the parade to the parish church on Whitsunday, where the Bishop of Gloucester preached the sermon to a packed congregation.

MOSS COTTAGE WYNDCLIFFE 380

Visitors relaxing in the rustic surroundings of Moss Cottage, *c.* 1910. This quaint haven for tourists was created at the bottom of the Wyndcliff in 1828 by the Duke of Beaufort's steward, Osmond Wyatt. He also had the 365 steps from the new road at the bottom to the top of the Wyndcliff made. Before the road separated them, the Wyndcliff was the highpoint of the Piercefield Walks. Its climbers were, and still are, rewarded by spectacular views, and many of the early Wye tourists waxed lyrical about it. After this experience Moss Cottage provided a pretty place to take tea, at a table made from a walnut-tree that once grew in Chepstow Castle ditch, inside small moss-covered rooms.

Right: Pausing for breath, and a photograph, on the path to the Wyndcliff.

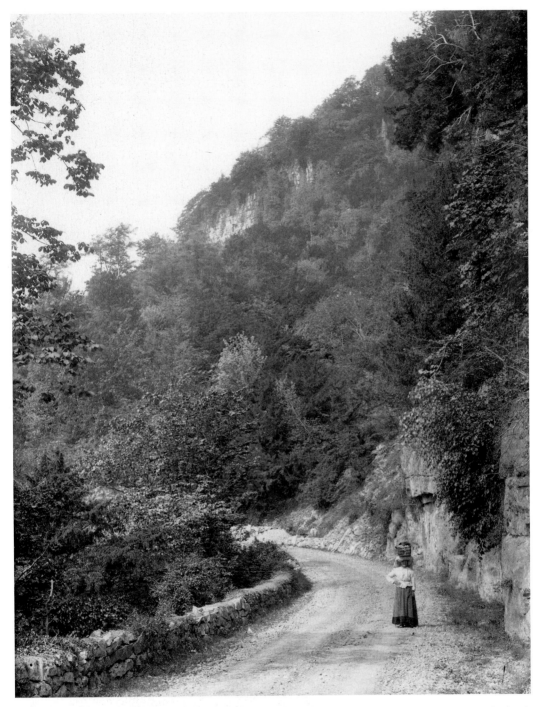

Making slow progress on the road beneath the Wyndcliff and using a traditional way to lighten the load. Before this road was made in the early 1820s the way to Tintern went through Porthcasseg.

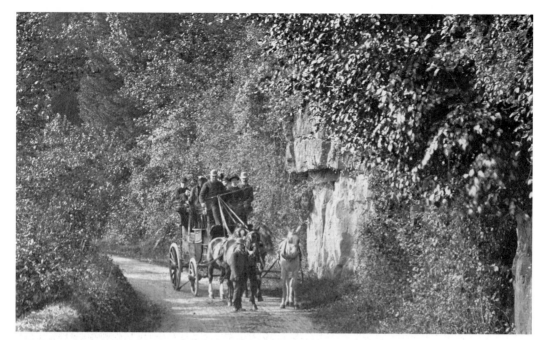

James Dobbs' four horse coach on the road near the Wyndcliff was a familiar sight in the summers of the late-nineteenth century when he drove tourists from Chepstow to Tintern and back. James Dobbs, the best known of all Chepstow coachmen, was much respected and his admirers presented him with a silver mail horn in 1875 for his gentlemanly conduct as a coach driver. He continued his service to Tintern until his death in 1893. The trip gave passengers an hour at the Wyndcliff and Moss Cottage, and two hours to explore Tintern.

The Beaufort Arms Hotel. Early tourists to Tintern, in the late-eighteenth and early-nineteenth centuries, found the keys to the Abbey in the custody of the landlord.

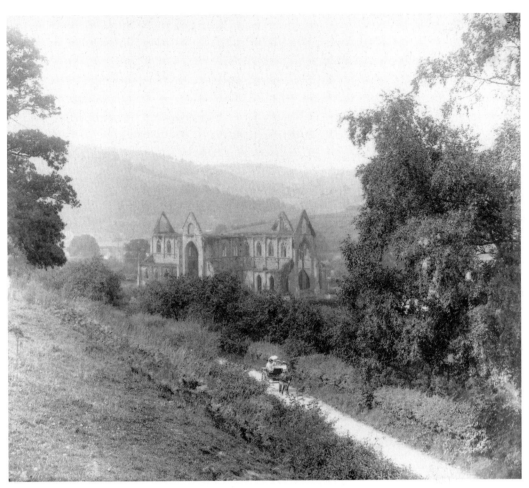

Travelling leisurely along the road, leaving Tintern behind. William Makepeace Thackeray, who toured the Wye Valley from Chepstow to Hereford in 1842, described his journey to Tintern and the moment when Tintern Abbey comes into view: 'A turn of the road brings you in sight of the green valley in which among orchards and little cottages reposing under its shadow, the noble old abbey of Tintern rises up. The river, to which stretch pleasant green pastures, lies a couple of furlongs off, and the whole of the valley is surrounded by high hills of wood on either side of the stream which give to the Abbey and the lands about it a beautiful air of repose and comfort.'

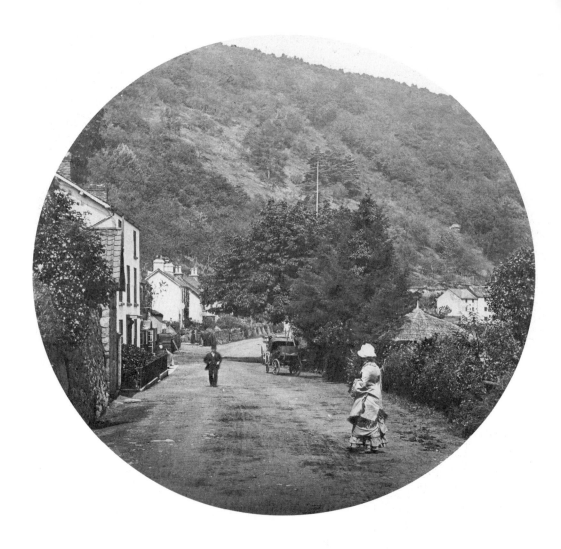

An 1880s view along the main road, (compare with top right, taken further down, by the Rose and Crown, at a later date). The sloping wall immediately on the left is still there but gone is the gabled building and the house next door rebuilt is now apartments. The porch and windows of the Rose and Crown protrude beyond. Further down, a lady stands by the steps of 'Melrose House'.

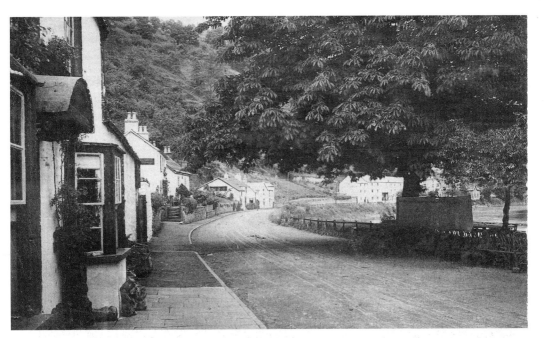

Outside the Rose and Crown *c.* 1900. A footpath has been made along the roadside. The chestnut tree, spreading its branches across the road in the photograph, has now gone.

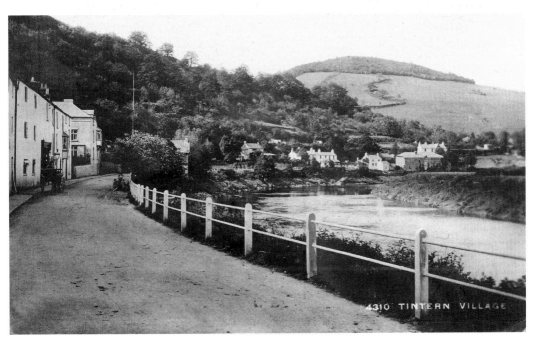

Further along, and later again, some familiar buildings can be picked out. Far right is the old rectory and immediately in front is the large riverside building now occupied by a garage. The second building to the left of this is the Moon and Sixpence, known as the Mason's Arms for over a hundred years until it was re-named by its landlord in 1948.

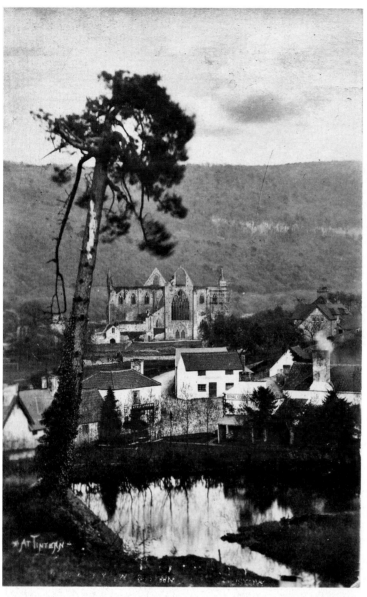

View across the mill pond, now partly the Royal George car park. The buildings pre-dating the old police station (1910) now surgery, and adjoining shop (1909) can be seen, including an early 'Abbey Stores'. Also visible, top right, are The Leytons, houses built in 1903.

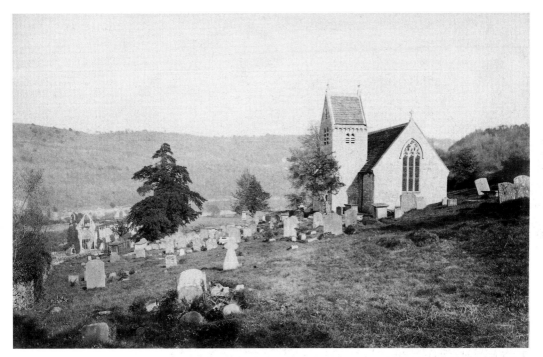

St Mary's, the parish church of Chapel Hill, virtually rebuilt in 1866, since its closure it has been devastated by vandalism. Tintern, although known as a single large village, was two parishes, Tintern Parva and Chapel Hill, and the prestigious occupant of the latter gave it an alternative common name of Abbey Tintern.

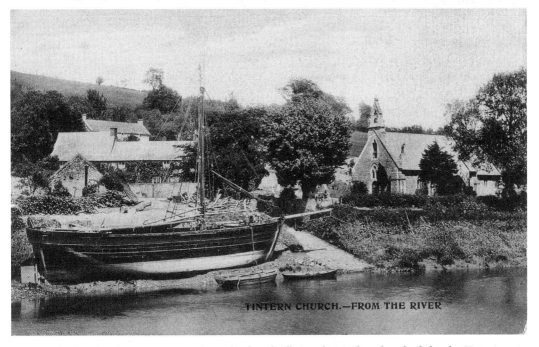

TINTERN CHURCH.—FROM THE RIVER

The parish church of Tintern Parva, St Michael and All Angels was largely rebuilt by the Victorians in 1846. Behind the wharf Parva farmhouse is visible, *c.* 1906.

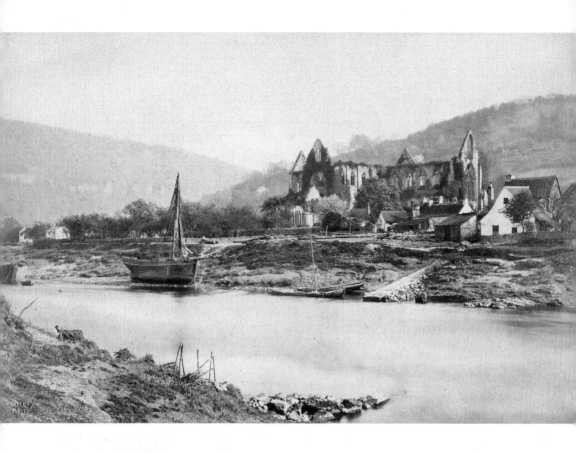

Above: View of the Abbey from across the river, with a trow on the riverbank. The trows carried goods to Chepstow and to Bristol. Wordsworth made this journey in 1798 and composed his 'Lines Written a Few Miles above Tintern Abbey' upon leaving Tintern and finished it as they arrived at Bristol. At that time the trade in timber and oak-bark was enjoying exceptional prosperity and vast quantities were transported on trows from Tintern to Chepstow. Most of the timber went to build ships for the Navy during the Napoleonic wars, while the oak bark was exported mostly to Ireland for the tanning industry. The ferry slip can be seen clearly.

Left: The ferry arch by the Anchor Hotel. The ferry led to a track called Abbey Road leading to Devil's Pulpit, Madgett and St Briavels, *c.* 1906.

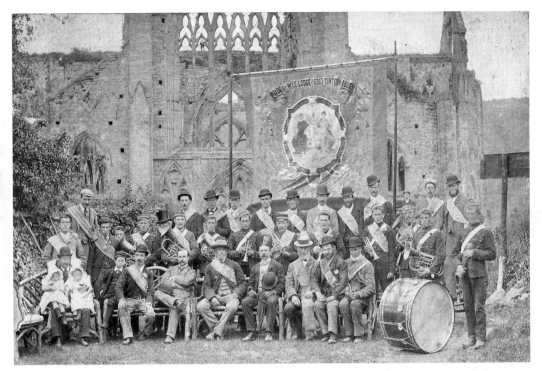

Members of the Pride of the Wye Lodge, Tintern Abbey, Manchester Unity of Oddfellows. The lodge was in existence from 1863–1922 when they amalgamated with Trellech. Apart from the social life that Friendly Society gatherings gave at their headquarters, the Rose and Crown, they provided a form of social security. Usually by paying into a common fund members became entitled to sickness and funeral benefits. Any names and information please.

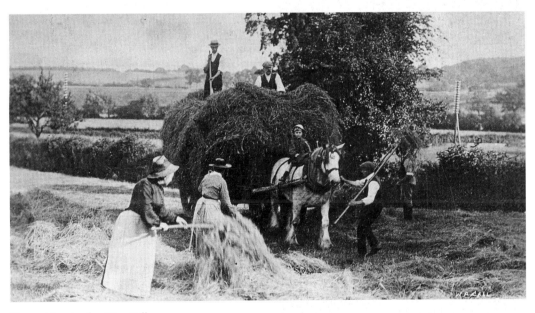

Haymaking in the Wye Valley.

Above: Tintern Abbey, north transept.

Below left: Visitors outside the main door in the west front, 1860s.

Below right: The nave looking east, at the same date. The smooth turf was laid down when the Duke of Beaufort had the church cleared of 'debris' and the ground levelled in 1756. Sculptural fragments were laid in 'picturesque confusion' and the ivy was considered to add 'Nature's ornament to the decorations of art'.

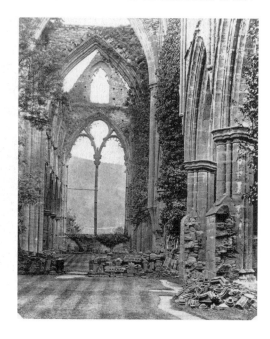

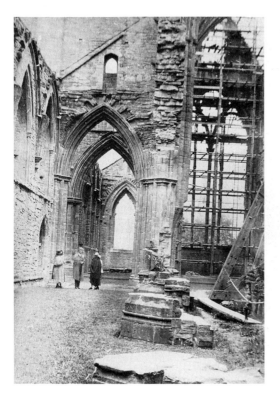 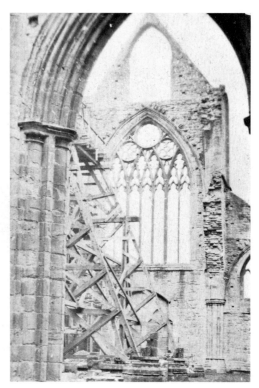

Above left: The north aisle and nave looking east. *Right:* Looking west showing timber shoring of the south arcade. After the Abbey was bought from the Duke of Beaufort by the Crown in 1901 work began on its preservation. From 1914 the Office of Works carried out major repairs. The destructive ivy was removed and the south nave arcade and clerestory was saved by rebuilding the supporting columns with steel cores. Romanticism was replaced by research and renovation.

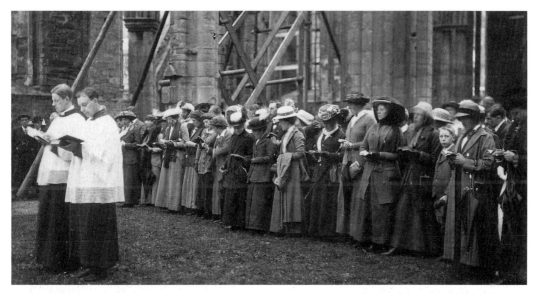

A service held in Tintern Abbey church at the time of the First World War.

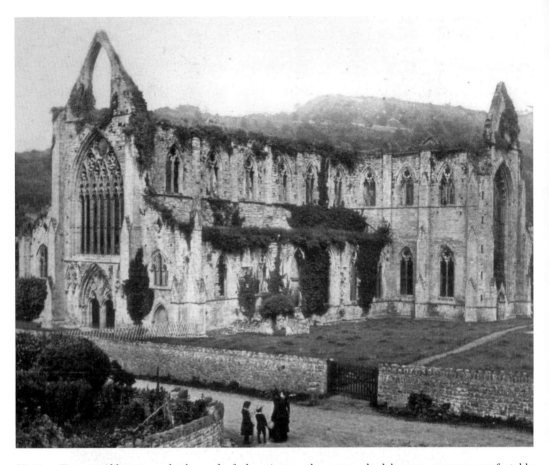

Visiting Tintern Abbey towards the end of the nineteenth century had become a more comfortable experience. Earlier tourists, before they could be inspired by the 'grandeur and sublimity' of the ruins, had to pass 'a miserable row of cottages' and force their way through 'a crowd of importunate beggars', Archdeacon Coxe recorded in 1801. William Gilpin, whose book *Observations on the River Wye* guided many disciples travelling in his wake, disliked the regular shape of gable ends and thought that a 'mallet judiciously used (but who durst use it?) might be of service in fracturing some of them ...'.

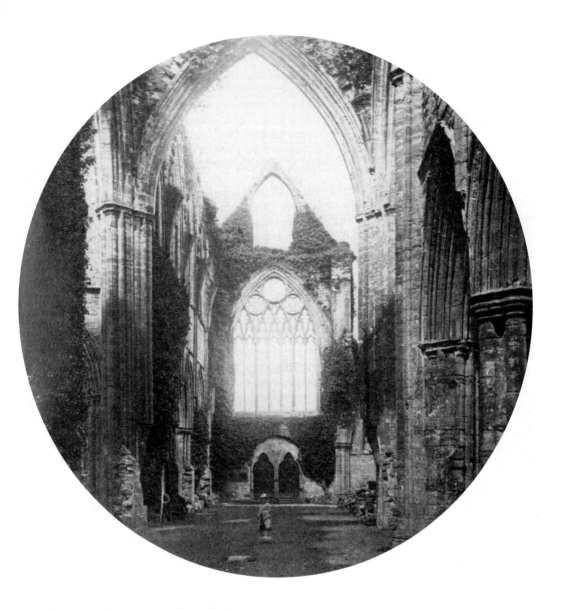

A visitor in the 1880s caught by the photographer standing in the nave, no doubt admiring the relics of the east window, while the viewer sees the perfectly preserved frame of the west window behind her. Descriptions, drawings and paintings of the scene abound. Thackeray thought no man should 'commit the impertinence to draw out a sketch-book', but fortunately they did, providing us not only with their vision but pictures of the place before the faithful eye of the camera opened on the scene.

ACKNOWLEDGEMENTS

It would be difficult to single out those people who have made identifications or given information about the particular photographs used in this book since, over the years, many people have helped to put names to faces and fit events to times and places not just of these photographs but also many others in the Museum collections. To all those who have ever done so, thank you. On a personal note, I have not only learnt a lot but immensely enjoyed listening and talking to you, and hope that more people will be prepared to come and share their knowledge and their memories.

No one can study Chepstow's history without immediately becoming aware of the breadth and depth of research accomplished by Ivor Waters and, moreover, made readily available to the public in his numerous publications. Yet his work for the preservation and understanding of Chepstow's history goes still further, with the Chepstow Society's establishment of the Museum which first opened in the Town Gate in 1949. Both he and his wife Mercedes worked indefatigably for the Museum, and I always remain indebted for the untiring help, advice, information and inspiration that Ivor gave me until his death, and that Mercedes, happily continues to provide.

In acknowledging those people specifically who donated the photographs used in this book, thanks are also extended to everyone who has ever given photographs to Chepstow Museum's collections.

Mr S.F. Aitken, Mr Bannister, Mr & Mrs Barnston, Mr A. Bigham, Hilda Bircham, Mrs N. Blandford, Mr G. Bleaken, Mr R.S. Child executors of Miss Clark, Mr H. Rimmer Clarke, Mr S.H. Clarke, Miss M. Clist, Mrs M. Collins, Mrs Crump, Mr Crumper, Mr G. Dade, Mr W. Dade, Mr D.T. Davies, Mrs R. Edwards, Mrs J. Ellis, Mr G. Evill, Fairfield-Mabey, Mr A. Farewell Jones, Mr G. Farr, Mrs C. Fisher, Cynthia Foster, Mrs A. Freeman, Mrs G. Goat, Mr E.W. Greene, Mr A. Griffith, Mr F. Griffith, Mr R. Habrook, Jillian Hartshorn, Mrs Hayward, Mr K. Howell, Mrs V. Howell, Mr J. Hubbard, Mr N.F. James, Mr B. Jarvis, Mr R. John, Mrs P. Johnson, Mr C. Gordon Jolliffe, Mrs Ellis Jones, Mr J.D. Jones, Mrs Jones, Miss Joyce, Mr S.W. Judd, Mr Kirton, Mr B. Lewis, Mr D. Lewis, Mr J.W. Manson, Mr C.P.C. Martin, Mr F. Neil, Mrs F. Park, Mr A. Pask, Mrs Pates, Mr N. Phillips, Miss V.M. Phillips, Mr W. Phillips, Mrs D. Powell, Misses Pritchard, Mr B. Rowlands, Mr Samson, Mrs D. Scott, Mrs Shaw, Mrs Squibbs, Mrs L. Swift, Miss D. Tamplin, Mr D. Thomas, Valerie Thompson, Mr J.P. Thorne, Mr H.L. Warren, Miss A. Waters, Mr I. Waters, Mrs K.E. Waters, Mr G. Watkins, Mr R. Watkins, Mrs J. Watson, Mr M. Weaving, Mr E.B. Whalley, Mrs White, Mrs Wilding, Mr J. Williams, Mr D. Woodgate, Mr M. Zorab.

Quotations used in the text are taken from contemporary reports in local newspapers: The *Chepstow Weekly Advertiser*, The *South Wales Daily* and *Weekly Argus*; from advertisements in Chepstow trade directories and programmes, etc, in the Museum's collections.